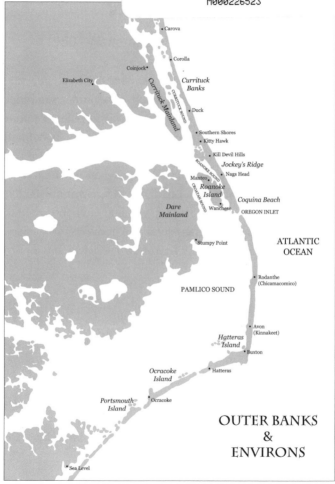

- Carova

- Corolla

Coinjock •

Elizabeth City •

Currituck Banks

Currituck Mainland

CURRITUCK SOUND

- Duck

- Southern Shores
- Kitty Hawk

- Kill Devil Hills

Jockey's Ridge

ROANOKE SOUND

- Nags Head

Manteo •

CROATAN SOUND

Roanoke Island

Coquina Beach

• Wanchese

OREGON INLET

Dare Mainland

• Stumpy Point

ATLANTIC OCEAN

• Rodanthe
(Chicamacomico)

PAMLICO SOUND

• Avon
(Kinnakeet)

Hatteras Island

• Buxton

Ocracoke Island

• Hatteras

Portsmouth Island

• Ocracoke

OUTER BANKS
&
ENVIRONS

• Sea Level

Published by The History Press
Charleston, SC 29403
www.historypress.net

Front cover: D. Victor Meekins Collection, OBHC; Steve Hillebrand, USFWS; HABS Collection, Library of Congress; State Archives of North Carolina; Tori Murden McClure; Aycock Brown Collection, OBHC. *Back cover*: Aycock Brown Collection, OBHC.

First published 2014

Manufactured in the United States

ISBN 978.1.62619.282.9

Library of Congress CIP data applied for.

On This Day In

OUTER
BANKS
HISTORY

SARAH DOWNING

Charleston London

THE
History
PRESS

CONTENTS

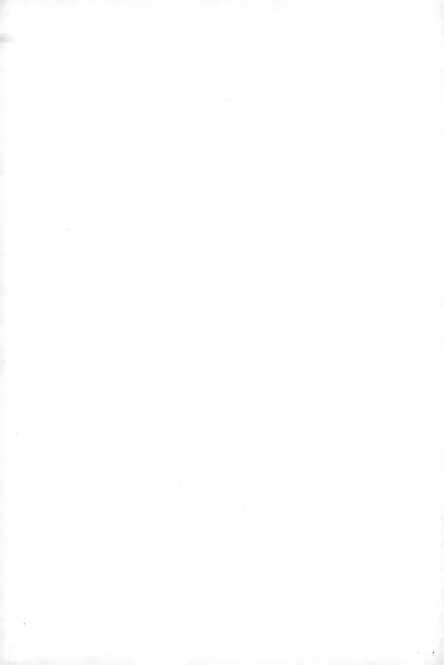

ACKNOWLEDGEMENTS

Compiling a book takes lots of energy, patience, time and help. I would like to thank the following people for their generosity:

Heather Trentzsch, assistant tournament director with the Pirate's Cove Big Game Tournament, patiently answered my questions and provided me with access to old tournament programs.

John M. Havel, lighthouse researcher par excellence, shared his research notes on the Cape Hatteras Lighthouse at a time when my idea well was running dry.

Brandon W. Stilley, library technician at Joyner Library, East Carolina University, provided requested materials promptly and professionally as the folks at Joyner *always* do.

Angie Brady-Daniels shared her memories and a photo of *The Today Show* visit.

Tori Murden McClure found me a photo of her first transatlantic rowboat trip.

Dr. Frank Blazich, fellow history geek, shared documents he uncovered at the State Archives of North Carolina.

Jacksonville, Florida's Mitch Kauffman, aka The Mayor, fed my head with sweet stories of surf trips to Hatteras in the 1970s.

James Hussey from Tarboro recollected about his world-record bluefish catch.

Walter C. Gresham, Drew C. Wilson, Michelle Warren, Eve Trow Turek and Mike Booher granted permission to use their photographs. Big thanks!

Naomi Rhodes, reference librarian, Dare County Library, brokered information for me and was always cheerful and supportive.

Frank Edgcombe and Peggy Brown, Harvey Library, Hampton University, graciously mined old, obscure newspaper columns from the 1941 *New York Times*.

Deputy Kevin Duprey took time out to talk to me about his award-winning rescue.

Jami Lanier, archives technician for the National Park Service, Cape Hatteras Group, answered questions and helped locate photographs.

Connie Perkins, friend from the Prairie State, carefully read the manuscript and provided invaluable advice.

Stuart Parks II created an impressive map to supplement the text.

My brother, Stephen Spink, was always willing to listen and give advice.

Thanks especially to my husband, Steve, who cooked dinner many nights when I was busy writing.

INTRODUCTION

The idea for this, my fourth, book crystallized while working on my third. I got the inspiration from Lew Powell's *On This Day in North Carolina* (John F. Blair, 1996). I started to think about a similar book for the Outer Banks. I could write about the August 18, 1587 birth of Virginia Dare; December 17, 1903, and the Wright brothers' first flight; and March 7, 1962, when the Ash Wednesday Storm left its calling card. After that, all I had to do was come up with 362 additional items of interest for the remaining days of the year. I was sure I could do it. The Outer Banks has a vast and vibrant four-hundred-year history ripe with a variety of tales.

I chose not to include too many storm or shipwreck stories, for they alone could fill a book. I did include many accounts of the gallant men and women who serve(d) in the U.S. Coast Guard and its predecessor, the United States Life-Saving Service, and many episodes that reflect

the fishing and maritime heritage of the area and its surrounding waters. I hope you enjoy reading about them as much as I enjoyed discovering them.

January 1

1977—Baby Born in 'Copter

Hospital Corpsman J. Silva delivered a New Year's Day baby aboard a U.S. Coast Guard helicopter dispatched from Air Base Elizabeth City. Twenty-five-year-old Betty Spittler, wife of coastguardsman Carson Spittler, stationed at the Ocracoke Coast Guard Station, went into labor before dawn on remote Ocracoke Island, accessible only by air or water. With no doctor available on the island, the helicopter was sent to transport Mrs. Spittler to Albemarle Hospital in Elizabeth City. The healthy baby weighed in at six pounds, five ounces.

JANUARY

January 2

1948—Crew Rescued from Menhaden Boat
Near Ocracoke

During a winter gale, the men of the Ocracoke Coast Guard Station rescued the crew from the 113-foot fishing vessel *Charlie Mason* during the early morning hours. A black crewman from the fishing boat died when he abandoned ship into the frigid ocean water. The vessel was later driven onto the beach on Ocracoke Island. The New York menhaden boat, valued at $125,000, carried a crew of twenty-one. After the grounding, Coast Guard crews worked for days with heavy equipment to refloat the stranded boat. The story of the vessel was preserved after Charles Stowe of Ocracoke wrote a folk song, "The *Charlie Mason* Pogie Boat."

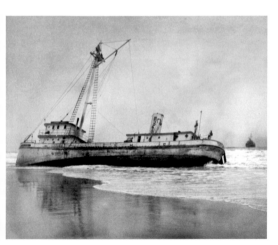

The *Charlie Mason* beached at Ocracoke. *D. Victor Meekins Collection, Outer Banks History Center, 1948.*

January 3

1933—County Wants Electricity, Now!

After P.D. Midgett Jr. submitted an application for an electricity franchise to supply power to county beaches, the Dare County Board of Commissioners gave Roanoke Utilities ninety days to begin extension of utility lines to Nags Head and Kill Devil Hills. Of special concern was electricity for the newly erected Wright Brothers Memorial. Woodson B. Fearing of Roanoke Utilities said plans were to begin extension of the lines in July and that Kitty Hawk would be included in the area to receive power. Fearing noted that the federal government would not have money to light the memorial beacon until that time.

January 4

1993—Williamsburg Family Finds Equipment from Ill-Fated Ship

The Nickerson family made an unusual discovery while beachcombing at the Pea Island National Wildlife Refuge. Mr. and Mrs. Nickerson and their son, Jon, who were vacationing from Williamsburg, Virginia, found a fire extinguisher and an emergency signal beeper that belonged to the vessel *High-Liner*, which had sunk at Oregon Inlet five days earlier. The thirty-one-foot workboat went down after being hit by a large wave while attempting to cross the bar with other boats after a day of fishing. Captain Thomas Carter Melton and mate Scott Basnight were wearing exposure suits with floatation because of the dangerous conditions at the time of crossing. The men were rescued by the trawler *Genesis*, which was in the line of boats entering the inlet together. The Nickersons returned the equipment to Captain Melton.

January 5

1895—Solo Sojourner Seeks Succor

A man traveling alone along the beach became sick during his journey and stopped at the Currituck Inlet Life-Saving Station. He was treated with medicine from the station's medicine chest and spent the night at the station. Feeling much better the following morning, the traveler continued on his way. In addition to rescuing shipwreck survivors or averting mishaps at sea, sheltering wayward travelers and offering assistance in isolated outposts was another type of assistance often performed by the United States Life-Saving Service.

January 6

1968—Kerosene Lamp Saves Fishermen

Two New Jersey fishermen ran their trawler *Viking* aground in Pamlico Sound during one of the nastiest winter storms in decades. They had no radio, and their searchlights garnered no attention. After remaining on the stranded vessel for four days, they set out for Portsmouth Island in a dinghy. After the pair arrived on the island, they spotted the light of a kerosene lamp burning in a small cottage, where a waterman was reading, unable to sleep. He gave the men some coffee and beans and called the Coast Guard on an emergency telephone the following day.

January 7

1991—Osprey Nests Allowed to Stay

After three years of osprey observation, Currituck County commissioners agreed to continue an arrangement with North Carolina Power to maintain special osprey nesting platforms constructed on abandoned utility poles adjacent to the Wright Memorial Bridge. The concrete platforms, built in 1987, worked to encourage ospreys to build their nests on them and to keep ospreys away from active power lines. Since their installation, the number of nests on the platforms increased from one to three to six active sites. The black-and-white birds of prey, known for their massive nests built over or near water, live on a diet of fish.

January 8

1957—Officers Elected to Waterfront Improvement Committee

Manteo photographer Dan Morrill was elected to serve as chairman of the recently created Manteo Waterfront Improvement Committee. The group, sponsored by the Manteo Rotary Club, Manteo Lions Club and the Dare County Power Boat Association and supported by the Manteo Board of Commissioners, had several ideas for upgrading the town waterfront to make it more attractive, interesting and user-friendly for both visitors and residents. Public bathrooms, a clubhouse, slips for traveling boaters, a park and picnic tables were suggestions for amenities that would bring citizens, summer people, boaters and sports fishermen to the Manteo waterfront. Also named to the Improvement Committee were Keith Fearing, John Wilson, C.S. Meekins, F.W. Meekins, Raymond Wescott, John Ferebee, Martin Kellogg, Ralph Davis and Guy Lennon.

January 9

1982—Oregon Inlet Closed to Large Vessels

Until a dredge was able to remove shoaled sand at Oregon Inlet, the passageway between the Atlantic Ocean and Pamlico Sound was closed to vessels that drew more than five feet of water. The Coast Guard made the decision after three trawlers got stuck, although the vessels were able to free themselves. High winds caused the worst shoaling in two years, and officials described the inlet as dangerous. Fishermen and those with interests in the fishing industry feared the economic repercussions that a closed inlet would bring.

January 10

1956—Windblown Sound Strands Hunters

The Coast Guard rescued six stranded sportsmen and women from a club on Swan Island. After a severe northwest wind blew water out of the Currituck Sound, the group of eight became marooned. When supplies dwindled, two of the stranded set off on foot through the muddy and icy marsh to the Currituck Beach Lighthouse. An H-94s helicopter from Coast Guard Air Station Elizabeth City flew the group—a doctor and his wife from Baltimore and a married couple and two singles from Providence, Rhode Island—to Norfolk to await further transportation.

January 11

1918—Makeshift Ice Boat Delivers Goods to Lighthouse

William B. Gray of Avon, a ship's cook with the U.S. Naval Reserve, carried provisions to Keeper Pugh, of the Roanoke Marshes Lighthouse, who had been isolated for up to three weeks because of a frozen Croatan Sound. Gray made the trip to the screwpile light, located off the lower west side of Roanoke Island, in a ship's boat to which runners had been attached. Secretary of the Navy Josephus Daniels recognized Gray for his selfless actions.

January 12

1959—Icebound Couple Airlifted

After being icebound for days, a Coast Guard helicopter airlifted a Reidsville, North Carolina doctor and his wife from Monkey Island in the frozen Currituck Sound. The couple was on a hunting trip with three others when ice six inches thick prevented boat access to and from the island. The doctor needed to return to his practice, and his wife needed to check in on her aging mother. When supplies at the lodge dwindled, the hunters contacted guide Rowland Twiford on the mainland, who arranged an airdrop of food by the Coast Guard. It was reported that the hunting party got its limit the first day out.

January 13

1978—Fisherman's Bid Highest for Coast Guard Station

After an auction on the steps of the Dare County Courthouse, commercial fisherman Captain Hiram C. Gallop was the highest bidder for the ten-acre Chicamacomico Life-Saving Station site at Rodanthe. Gallop's bid of $50,000 topped all others; however, there was a ten-day period where additional bids were received. Gallop said he was descended from Captain John Allen Midgett, who served as keeper of the Chicamacomico Station and was famous for his participation in the rescue of survivors of the torpedoed ship *Mirlo*. Gallop had no immediate plans for the historic buildings on the property.

January 14

1952—Deer Reintroduction

In an attempt to bring back the deer population of Duck, Kitty Hawk and Nags Head Woods that had been decimated by overhunting, North Carolina Wildlife Resources Commission representatives released a young doe on the Catco Lodge property near Martin's Point. Wildlife officials believed that with the addition of the doe, the population in the area now numbered five deer: three does and two bucks. State game wardens closely monitored the deer population and believed that local sentiment was behind the reintroduction program. The population rebounded such that today there are limited hunting seasons in both Kitty Hawk Woods and Nags Head Woods.

January 15

1956—Phone Service at Ocracoke

Islanders and telephone company personnel attended a small ceremony to celebrate Ocracoke Island's new telephone service. At noon on a Sunday, Ocracoke promoter, businessman and native Stanley Wahab made the first commercial telephone call from the island. North Carolina State Utilities Commission chairman Stanley Winborne was the receiver of the historic call. Prior to commercial service, island natives relied on the U.S. Coast Guard to relay emergency messages. It was estimated that fifty residents would subscribe to the long-distance service, which was facilitated by the radio link. The new telephone service was projected to benefit the isolated island's fishing and tourism industries.

January 16

2005—Whale Stranding

Scientists and National Park Service employees, working in cold and blustery conditions, were at Coquina Beach south of Nags Head to collect samples and to clean up following a mass stranding of pilot whales discovered the day before. Thirty-four whales were found by a beach walker along a five-mile stretch of beach administered by the National Park Service. The seven that did not die of natural causes were euthanized to relieve their suffering. Necropsies were later performed on the marine mammals. Experts and whale defenders tried to determine if the use of sonar by the U.S. Navy was the cause of the mass beaching. The navy reported that the U.S. Kearsarge Expeditionary Strike Force conducted antisubmarine operations on the day of and the day prior to the strandings.

January 17

1973—Trawler Hit at Sea

The Wanchese-based trawler *Wayne Lauren* was struck and sunk eight miles off Cape Hatteras. Its crew of five escaped injury and was rescued by another Wanchese trawler, *Mitzi Kay*. The Coast Guard dispatched an aircraft and the cutter *Cape Upright* to inspect the scene. Two foreign freighters, the 506-foot Greek ship *Hellenic Laurel* and the 461-foot Danish ship *Thyra Torm* were in the vicinity of the sinking. The *Cape Upright* was ignored when its crew attempted to make contact with the Danish ship via radio, signal flag and flashing lights. The Coast Guard inspected each of the foreign ships, but a language barrier hindered the investigation.

January 18

1971—Baby Born on Boat

An Ocracoke woman went into labor in the early morning hours and was put aboard a Coast Guard utility boat on the island's north end. While en route to Hatteras Island, the vessel grounded on a shoal. A radio call was sent, and a Coast Guard hospital corpsman was dispatched via helicopter. The corpsman was lowered onto the stranded ship in the predawn darkness. He was met by an area doctor, who arrived in another boat. They made it in time to deliver a seven-pound baby girl. Both mother and daughter came through the birth at sea in ship shape.

January 19

1976—Roanoke Island Woman Selected as "Carolina Conservationist"

Newspaper reporter and managing editor of the *Coastland Times* Vera Evans of Manteo was presented the Carolina Conservationist award by the North Carolina Association of Soil and Water Conservation Districts. The outgoing and congenial Evans was given the award for her contributions to conservation awareness through her writing and photography. During the awards ceremony, held at the thirty-third annual meeting of the association that convened in Winston-Salem, North Carolina, it was noted that the sixty-year-old Evans not only "preaches conservation" but also "practices it at home in her garden."

January 20

1995—Newspaper Office Burns

Fire damaged the Nags Head office of the *Virginian-Pilot and Ledger Star*. A defective computer terminal was thought to be the cause of the blaze that occurred on a Friday evening when the building was vacant. Reporters, photographers and staffers arrived on the scene after learning of the tragedy. Editor Ron Speer was visibly saddened by the fire, but he called a meeting the following day to chart the course of the newspaper. Thousands of negatives and photographs of staff photographer Drew C. Wilson were salvaged and later donated to the Outer Banks History Center in Manteo.

January 21

1891—Law Authorizes Force in Oyster War

When overharvesting depleted oyster stocks along the Chesapeake Bay, scores of vessels from Virginia and Maryland equipped with oyster dredges showed up to harvest North Carolina oysters. A law went into effect on this day authorizing the governor of North Carolina to use military force for a three-month period to clear the state's waters of out-of-state oyster dredgers. This allowed time for legislators to create a comprehensive set of laws governing North Carolina's valuable oyster fishery. Governor Daniel G. Fowle employed a vessel and ordered a company of the North Carolina National Guard to perform oyster patrols, which proved effective in clearing the sounds of out-of-state competition.

January 22

1958—Testimony Given on Value of Live Oaks

The second day of hearings took place at the Dare County Courthouse, where experts placed values on a group of live oak trees on the shores of Kitty Hawk Bay that had been recently cut down. The trees, some of which were thirty inches in diameter, were removed by the Virginia Electric and Power Company (VEPCO) in order to create a right of way for power lines. Tree experts, two local realtors, the Dare County tax supervisor and VEPCO representatives testified, giving their opinions on the value of the property before and after the trees were cut down, the difference being the value of the trees. While values ranged from $300 to over $4,000, a court-appointed committee valued the trees at $600.

January 23

1950—Hatteras Beacon Shines Again

Following a fourteen-year hiatus, the Cape Hatteras Lighthouse, America's tallest brick lighthouse, was relit. During the 1930s, severe erosion caused the beacon to be abandoned. At one point, the encroaching ocean was just one hundred feet from the lighthouse's base. To take its place, a new light was activated on a tall steel structure, known as the skeleton tower. The Civilian Conservation Corps' sand-fixation and dune-building project helped to stabilize the beach. The 208-foot lighthouse was again threatened by erosion and, in 1999, was moved 2,900 feet inland.

January 24

1874—Black Justice Marries White Couple

Roanoke Island's George Riley Midgett, black justice of the peace, performed a marriage ceremony for a young, white Nags Head couple. Nineteen-year-old Solomon Beasley and his bride-to-be, Senia O'Neal, traveled via boat across the Roanoke Sound and were anxious to make the return trip before the weather turned. Midgett, who was known locally as Uncle George, grew up on Roanoke Island, held office as a Dare County commissioner and also served in the U.S. Life-Saving Service at the Pea Island Station. George Riley Midgett was also known for his windmill on Roanoke Island.

January 25

1989—Grass-Roots Opposition to Offshore Drilling

At an informational meeting at Manteo High School, officials from Mobil Oil were met by a group of three hundred citizens whom the *New York Times* described as "skeptical" and "sometimes hostile." At stake was a tract forty-seven miles off Cape Hatteras that the U.S. Department of the Interior Minerals Management Service intended to lease, and Mobil Oil was interested. Area locals from Ocracoke

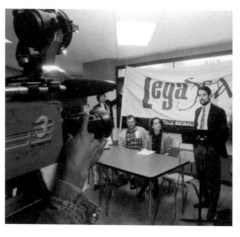

Michael McOwen, cofounder of LegaSea, an organization created to thwart plans to drill off North Carolina's coast, meets the press in front of an information booth at a public hearing about Mobil Oil's proposal to explore off the Outer Banks. *Drew C. Wilson Collection, Outer Banks History Center, 1989.*

to the North Banks had organized and created a group, LegaSea, to fight the big oil companies. At a public hearing later in the year, Senator Marc Basnight and Congressman Walter B. Jones Sr. went on record opposing Mobil's plans to drill off the North Carolina coast.

January 26

1978—Electrical Outage Darkens Cape

Gale-force winds, a power outage and a failed backup generator caused the Cape Hatteras Lighthouse to stop shining. The blackout went unnoticed until the missing signal was detected and reported by officials who were at work at the LORAN station two miles away. The lighthouse was darkened for forty minutes before being restored.

January 27

1985—Transportation Workers Break Up Ice

Employees of the North Carolina Department of Transportation (DOT) took to boats to break up ice floes near the Washington Baum Bridge over the Roanoke Sound. A deep freeze five years earlier had caused ice to take out two of the bridge's pilings and damaged many others. After reports of chunks of ice six feet high, the work by the DOT was seen as a preemptive measure to keep any new damage from taking place to the bridge's wooden pilings. The swing-span bridge that replaced the original structure in the 1950s was in turn scheduled to be replaced within the decade by a new high-rise concrete bridge.

January 28

1994—Leaders Meet to Determine Plan for Jockey's Ridge

State and local officials met with representatives of the Friends of Jockey's Ridge to determine the best course of action to bring to fruition a visitors' center and a concession center at Jockey's Ridge State Park. While the Town of Nags Head had recently passed a resolution favoring the construction of the visitors' center, others believed that both amenities could come about at the same time and cited efficiency in spending as a chief motivator. The estimated cost of the additions to the park were $435,000 for the concession building, from which adventure seekers could arrange hang-gliding trips, and $500,000 for a visitors' center. Jockey's Ridge was and continues to be the most-visited state park in the North Carolina State Park System.

January 29

1962—Bids for Oregon Inlet Bridge Reviewed

The North Carolina Highway Commission opened and reviewed bids received to construct the Herbert C. Bonner Bridge across Oregon Inlet. Engineers working for the state estimated that the price of building the bridge would be $4,000,000, but Baltimore's McLean Construction Company submitted a bid of $3,977,333. The T.A. Loving Company based in North Carolina, the construction firm that built the William B. Umstead Bridge across Croatan Sound in 1957, was reported as submitting a bid just $20,000 higher than the McLean bid. After a bid was accepted, the company awarded the contract would have three or four months to deliver its equipment and begin the project.

January 30

1972—Monster Bluefish Caught at Inlet

James Hussey poses with his world-record bluefish, caught near Hatteras Inlet. *Aycock Brown Collection, Outer Banks History Center, 1972.*

While trolling aboard the boat *Mary K* in Hatteras Inlet, James Hussey of Tarboro, North Carolina, landed a thirty-one-pound, twelve-ounce bluefish on a Jig-A-Doo lure. He and a friend had been taking turns fishing and driving the boat when Hussey caught the only fish of the day. The men took the bluefish to Red Drum Tackle at Buxton, where it was weighed, but the scales were not certified. Red Drum owner Ray Couch telephoned photographer Aycock Brown in Manteo to let him know the anglers and the prize fish were on their way. After an official weighing, Hussey's catch was certified as a new world record that stands to this day.

January 31

1948—Coastguardsman and Friend of Wrights Dies

John T. Daniels Jr., the retired coastguardsman who assisted the Wright brothers, died in a Norfolk hospital. Daniels was a surfman at the Kill Devil Hills Life-Saving Station when he photographed the Wright brothers' historic first flight using the Wright brothers' Gundlach Korona box camera. The image, one of the most recognizable photos in the world, captured the moment when Orville Wright made history as their flyer lifted off the sands near Kill Devil Hills. Later that day, a gust of wind caught the flyer, and Daniels became entangled in the plane's wires while trying to keep it from blowing away. He enjoyed telling the story of how he became the first man injured in an airplane mishap. The Manteo native was stricken with a heart attack the day before, hours prior to the death of Orville Wright in Dayton, Ohio.

February 1

1891—A New Light Shines in the Pamlico

After five months, work was completed on the new Gull Shoal Light in the Pamlico Sound, and the screwpile lighthouse was ready to display its beacon. The wooden, six-sided structure rested on seven ten-inch metal pilings and was lighted by a fourth-order Fresnel lens with a fixed red signal. During times of fog, a bell sounded by machine, the pattern being two rings every fifteen seconds. Construction of the station was delayed when initial pilings were set because the ground provided an insufficient foundation due to the soft bottom of the sound. Each piling was fitted with a specially made cast-iron sleeve with a five-foot disk. The addition of the sleeves and disks created a much more stable base.

February 2

1976—Manteo Officials Get Late-Night Phone Call

The Dare County Sheriff's Department telephoned Manteo commissioners and business owners to warn them of predawn flooding downtown during a winter storm with dangerously low barometric pressure. A number of downtown stores were inundated with water, including Dare Hardware, Ben Franklin and Fearings. As the storm passed,

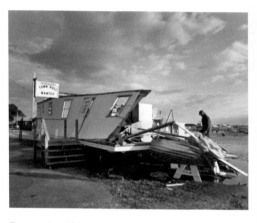

Remnants of Manteo's temporary town hall after a storm system with a quick drop in barometric pressure blew out the walls. *Photo by J. Foster Scott, Outer Banks History Center, 1976.*

the pressure rose, which caused the walls of the temporary Manteo Town Hall (a trailer across from the post office on Queen Elizabeth Street) to push outward. The structure exploded. Damage from winds estimated as high as eighty miles per hour was visible when fences and signs were blown down, a boat was moved off its trailer and a plane was flipped over at Manteo Airport.

February 3

1952—Vessel Midget Grounds at Portsmouth

The Panamanian freighter *Midget* grounded fast on the beach at Portsmouth Island just after 10:00 p.m. *Midget* lost radio communication, and although chances of finding it were scant, a Coast Guard plane out of Elizabeth City sighted a flare from the unfortunate ship. Its captain and crew abandoned the 2,600-ton, 230-foot ship in the early morning hours when *Midget* began to break apart in rough and stormy seas. All twenty-six men took to one life raft and, in a stroke of good fate, were pushed ashore by the foamy seas. A month later, commissioner of wrecks Alpheus W. Drinkwater held a vendue, or auction, to disburse the goods aboard the ship. It was the first vendue in many years and one of the last of this type held along the North Carolina coast. Items sold—paint, a compass, canvas and a container of cream cheese—yielded just $163.

February 4

1931—Ceremony Marks Start of Wright Memorial

After stabilizing the massive sand dune Big Kill Devil Hill, groundbreaking took place for the foundation of the Wright Brothers Memorial. John A. DeWitt, quartermaster general, turned the first shovel of dirt. The dune was made stationary by the planting of native shrubs and native and imported grasses. A fence was constructed around the property to keep free-ranging livestock from snacking on the new growth. The sixty-one-foot granite monument was completed in October 1932 and dedicated the following

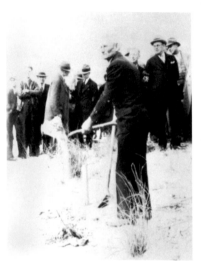

William Tate breaks ground for the Wright Brothers Memorial. *State Archives of North Carolina, 1931.*

month. On hand to watch or participate in the ceremonial groundbreaking was Johnny Moore of Colington Island, a witness to the Wrights' first flight in 1903; Captain William Tate, who assisted the Wrights during their stays in Kitty Hawk; and W.O. Saunders, president of the Kill Devil Hills Memorial Association.

February 5

1847—First Ship Sails Through Hatteras Inlet

The schooner *Asher C. Havens*, piloted by Redding Quidley, became the first vessel to sail through Hatteras Inlet into Pamlico Sound. The new passage to the sea was cut during a ferocious hurricane on September 7 and 8, 1846. It was the same storm that was responsible for the creation of Oregon Inlet, which was named for the first vessel to navigate its waters in 1848.

February 6

1963—High Winds and Waves Hinder Work on Closing Inlet

Volunteer workers on Hatteras Island continued to try to fill in the Ash Wednesday Storm Inlet cut north of Buxton almost a year earlier. The 1,500-foot breach, filled with over two hundred junked cars and twenty thousand sandbags, was closed to within one hundred feet

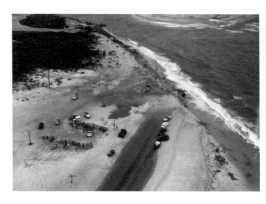

Water flows through the Ash Wednesday Storm Inlet. The breach was almost closed when a nor'easter the following year widened the opening. *Aycock Brown Collection, Outer Banks History Center, 1963.*

when a high-powered winter nor'easter severed the island again. National news media was following the efforts to close the inlet, including CBS, which sent cameraman Nelson Bentley from the Atlanta bureau to gather footage of the scene. Citizens were reported on the brink of sickness and exhaustion. The following day, a false rumor surfaced that an additional inlet had been formed.

February 7

1862—Union Troops Land to Secure Roanoke Island

After the morning fog lifted, a convoy of Union transports and gunboats proceeded north up the Croatan Sound toward Roanoke Island, which was heavily fortified by Confederate troops. Ships fired on the earthworks, Fort Bartow in particular, in a manner described as "not rapid, but well directed." Confederates returned fire from the island and from their sparse navy, known as the Mosquito Fleet. In the afternoon and into the evening, Union troops landed at a spot called Ashby's Harbor midway on the west side of the island. There, the soldiers spent an uncomfortable, rainy night huddled around campfires. The landing site was suggested by Tom Robinson, a young runaway slave.

February 8

1862—Outnumbered Confederates Surrender on Roanoke Island

Union troops, who had encamped at Ashby's Harbor overnight, assembled and advanced north on Roanoke Island. Confederates, who were greatly outnumbered, believed the island to be impenetrable because of its swampy terrain. They were entrenched in the center of the island behind a three-gun battery. The Federal soldiers advanced on the right, left and center and were ordered to attack. The sight of the charging Yankees caused the outnumbered Confederates to flee north along the only road on the island, abandoning haversacks, knapsacks, knives and assorted accoutrements as they went. Between 2,500 and 3,000 prisoners were captured and sent to Elizabeth City for parole. A few escaped across the Roanoke Sound to Nags Head, where General Henry Wise was headquartered at the Nags Head Hotel, which he burned upon retreat.

February 9

1980—Although Restricted, Baum Bridge Reopens to Traffic

The Washington Baum Bridge was opened to traffic following a day-and-a-half shutdown. Large ice floes in the Roanoke Sound jammed up against the bridge, damaged pilings and created a sag in the structure. After an inspection by North Carolina Department of Transportation officials, the bridge was opened to one-lane traffic until the appropriate repairs could be made. A temporary stoplight on the bridge managed the single-lane traffic flow. Highway workers and equipment were brought in from Williamston, Greenville and little Washington. Four dragline excavators were put to work to break up the ice floes.

February 10

1962—Voters Say No to Wine and Beer Sales

Approximately 181 voters were undeterred by cold island weather and visited the polls in a special Saturday election to cast their ballots for or against the sale of beer and wine in Hatteras Township, the political unit made up of the villages of Buxton, Frisco and Hatteras. Voter turnout was the heaviest in the township since a vote on the same issue was conducted with Kinnakeet Township in 1953. Although each side had its supporters, in the end, the "drys" had more voter power, and both the sale of wine and beer (voted upon separately) were defeated. The night prior to the election, 125 people attended a "dry" rally held at Cape Hatteras High School. Many area churches were active in the campaign.

February 11

1998—Sweet Bounty from the Sea

Beachcombers and scavengers found sweet treasure along beaches from Currituck Banks to Oregon Inlet after shipping containers washed ashore bearing fruit. Honeydew melon and cubes of balsa wood came ashore at Corolla, while plantains were strewn along the sand at Nags Head. Fruity jetsam was loaded up in makeshift totes and carried off the beach by the armload and in the back of pickup trucks. A storm had caused thirty-six metal containers to wash off a South American freighter. Since the source of the cargo on the beach was known, it was technically not available for salvage, but that didn't matter to enterprising Outer Bankers.

February 12

1986—"Paint Bandit" Strikes Again

A second instance involving paint on Kill Devil Hills roads was reported by eight motorists who drove through metallic silver paint on Colington Road and had it splash up on their vehicles. The incident occurred about 10:00 p.m. near the airstrip adjacent to the Wright Brothers Memorial. Two patrol cars from the Dare County Sheriff's Department arrived on the scene and also drove through the paint, which reportedly "messed up" the vehicles. It was the second time within ten days that paint was spilled on Kill Devil Hills streets. Police in that town did not know if the spills happened on purpose or were unrelated mishaps.

February 13

1968—*National Geographic Photographs* Deering *Remains*

William Ellis, a writer on staff with the National Geographic Society, photographed Wheeler Ballance and the remains of the five-masted schooner *Carroll A. Deering*. Ballance, a service station owner on Hatteras Island, collected some old timbers and the capstan from the "ghost ship," which was discovered abandoned aground on Diamond Shoals in 1921. In order to keep the *Deering* from becoming a nuisance to navigation, it was blown up, and its remains washed ashore on Ocracoke, where they rested for a number of years. Hurricane Ione in 1955 set the *Carroll A. Deering* awash again, and this time it ended up on Hatteras. Ballance took the remains to his Texaco station for a tourist attraction.

February 14

1992—Seal Catches Ride with Coasties

After ten days of rehabilitation, a young harbor seal caught a ride on a Coast Guard patrol boat and was released a mile offshore. The seal was found on the beach at Hatteras Island sick and undernourished and was taken to the North Carolina Aquarium on Roanoke Island, where it received fresh fish and medication and was kept under a watchful eye until it regained its strength. It was the second seal of the winter found on local beaches, causing experts to ponder why the marine mammals, which usually stuck to colder New England waters, were showing up on Carolina beaches.

February 15

1966—Garden Architecture Firm Sends Rep to Roanoke Island

Richard Webel, of the New York–based garden architecture firm of Webel-Innocenti, designers of Elizabethan Gardens, visited that site joined by members of the Garden Club of North Carolina from across the state. During his sojourn, Webel shared plans for updating and expanding the Elizabethan Gardens that included modifications to the herb garden, a substantial addition to the gatehouse, creation of an appropriate entrance for service and maintenance work and adding to the existing garden wall. The Elizabethan Gardens was created to serve as a living memorial to the first English colonists in America.

February 16

1899—Manteo Becomes First Dare Municipality

The Roanoke Island town of Manteo incorporated on this day. The settlement on Shallowbag Bay had been the county seat of Dare County since it formed in 1870. Mayor William G. Forbes and six town commissioners signed the charter that made it official.

February 17

2003—Exhibit at History Center Highlights Meekins' Work

An opening reception was held at the Outer Banks History Center Gallery in Manteo to celebrate the debut of a new exhibit, "Aerial Views, Things in the News, the Beach of Yesteryear and Past Happenings Here: Black and White Photographs of Roger P. Meekins." The display was created in-house by History Center staff and included fifty images taken between 1949 and 1954 by island native Roger Meekins, the son of D. Victor Meekins, founder of the local newspaper, the *Coastland Times*. A chilly winter evening didn't dampen the spirits of the enthusiastic crowd that turned out for the event, which included remarks by the photographer.

February 18

1974—Burglary at the Home of Hollywood Star

A local woman who acted as a caretaker of Andy Griffith's Roanoke Island home found two teenagers in the garage of the film and television personality. The woman, who checked on the property twice a day, made the discovery during her evening visit. When she asked the youths what they were doing, they ran away on the beach in front of the home, but not before dropping a bag containing liquor that had been stolen from the Griffith property. The break-in was investigated by members of the Dare County Sheriff's Department and the North Carolina State Bureau of Investigation.

February 19

1991—Bonner Bridge Replacement Options Aired

Options for replacing the Herbert C. Bonner Bridge across Oregon Inlet were discussed at a public workshop organized by the North Carolina Department of Transportation. The four plans included building a tunnel, operating ferries or some sort of high-tech hovercraft (this counted as one option); replacing the existing bridge; or doing nothing. The purpose of the workshop, attended by few, was to present the choices for replacing the bridge and to answer any questions in a public forum. After information was gathered, an environmental impact statement would be created. The current bridge was predicted to last at least an additional eight to twelve years.

February 20

1965—Ferry Traffic Resumes Between Ocracoke and Carteret

After undergoing yearly maintenance at Barbour Boatworks in New Bern, the ferry *Sea Level* resumed its route from the Carteret County village of Sea Level to Ocracoke Island. Ferry service between these two points was suspended while the ferry underwent repairs and its annual inspection. The *Sea Level*, the largest and most comfortable vessel in the North Carolina ferry system, would make its trip across the Pamlico Sound once a day and would expand to twice-daily service later in the year with the influx of visitors to the coastal area.

February 21

2007—Trawler's Loss Is Sea Birds' Gain

The trawler *Lady Helen*, fishing out of Carteret County, ran aground in Oregon Inlet while heading to Wanchese with 100,000 pounds of croaker. The eighty-seven-foot wooden vessel hit bottom west of the Herbert C. Bonner Bridge and then hit a steel buoy, creating a gash in the trawler's side below the waterline. The captain grounded it in shallow water to avoid sinking. Three crew members were taken ashore and returned the following day to patch holes in the damaged trawler and to pump it out and float it. The estimated value of the *Lady Helen*'s finny haul was $20,000, and although half was lost, half was salvageable because the cold ocean kept the fish from spoiling. Any croakers that drifted away from the trawler were enjoyed by hovering gulls and pelicans.

February 22

1955—Navy Investigates Reported Sub Sighting

A Kitty Hawk woman sighted an object protruding from the ocean three or four miles offshore and, unsure of what it was, reported it to the Coast Guard. The Coast Guard in turn reported the sighting, and the navy sent a plane from Norfolk to begin an air search. A blimp was sent from the base at Weeksville. The following day, the search resumed; however, officials believed the water at the spot where the sighting took place was too shallow for submarine activity. The sighting was never confirmed. Other area residents espied the object, and several suggestions concerning its origin were presented. Many residents who did not see the unidentified object did much to fuel rumors.

February 23

1983—Darana R *Makes It Back to Wanchese Harbor*

The fishing vessel *Darana R*, loaded with fifteen tons of fish, made it back to Wanchese following a two-day adventure at Oregon Inlet. The incident began when *Darana R* struck a sandbar. A forty-four-foot Coast Guard vessel attempted to pull the stranded *Darana R* off the bar, but the towline broke several times. The next day, the eighty-two-foot *Point Arena* arrived from Station Little Creek in Virginia but was unable to get close enough to throw a towline to the fishing boat. The forty-four-foot Coast Guard motor lifeboat was able to secure the towline from the *Point Arena* to the *Darana R*, and the *Point Arena* tried to full-throttle to pull the ship off the bar. The line ended up entangled with the cutter's propeller and required a dive team to remove it. The U.S. Army Corps of Engineers dredge *Schweitzer* and the fishing vessel *Cheryl Ann* finally freed the *Darana R*.

February 24

1980—Area Puppets Make State Television Debut

An entourage of local puppets, directed by a troupe of local puppeteers, appeared on television on channel 7, WITN, in Greenville, North Carolina. The drama, in which the local puppets were featured, was funded by the North Carolina Arts Council and was presented fifty times in Dare County at shopping centers and local events before airing on television. The puppet show was about a band of mice that traveled across the Atlantic on one of the ships of the sixteenth-century Roanoke Voyages. Included in the cast were Her Mousejesty and Sir Walter Mousely. The television production aired at noon, with Kay Curry as hostess. It was the first television appearance for the puppets.

February 25

1958—Link to Currituck Opens After Repairs

The Wright Memorial Bridge was reopened to traffic at 11:00 a.m. after a five-day closing. North Carolina Highway Commission officials shut down the three-mile span connecting Point Harbor and Kitty Hawk after ice floes in the Currituck Sound damaged several pilings, seventeen of them severely. Maintenance crews worked through the weekend to repair the damage, which was concentrated in three portions of the span. A warming trend aided in the rapid repairs. It was reported that old-timers said the cold snap was the worst in forty years, since a thirty-day cold spell in the winter of 1917–18.

February 26

1977—Wildfire Summonses Multiple Fire Departments

Dry winter conditions led to a series of wildfires across North Carolina that burned over 1,800 acres. In Kitty Hawk, over 200 acres of marshland and an abandoned house were charred in a fire that county forestry officials believed was deliberately set. The blaze was brought under control by the work of eight volunteer fire companies, including Kitty Hawk, Kill Devil Hills, Nags Head, Roanoke Island, Southern Shores and the North Carolina Forestry Service. Four homes were evacuated as a precaution. Local businesses supplied coffee to the firefighters as part of an auxiliary effort. While local fire officials were confident that the fire was set intentionally, proving the suspected arsonist guilty would be a challenge.

February 27

1961—Highway Representative Promises Improvements to Ferries

Approximately 275 citizens of Hatteras and Ocracoke Islands attended a hearing at Cape Hatteras High School about improvements to Oregon Inlet ferry service. Merrill Evans, chairman of the North Carolina State Highway Commission, traveled from Raleigh to hear the concerns of island citizens. The request list included night ferry runs and expanded service until midnight, a ferry docked on the northern tip of Hatteras Island overnight so trips could begin simultaneously from both sides of the inlet each morning and the hiring of more skilled ferrymen. After the two-hour meeting, Evans left Hatteras Island on a specially arranged night ferry run across Oregon Inlet so that he might be in Raleigh the following morning.

February 28

1966—Drawbridge Strikes Fishing Vessel

While traveling inland to Tidewater, Virginia, on his trawler *Capt. John Duke*, Moon Tillett passed through the opened Roanoke Sound Bridge, but not before being struck by the swing span as it began to close. In a turn of good fate, the bridge did not hit the cabin but instead took out about fifteen feet of the trawler's side railing. The veteran fisherman was following the trawler *Esther Joy*, captained by Boyd Basnight. Damage to the *Capt. John Duke* was estimated at $500, but lost revenue would be much more costly. The boats were traveling through the sound because conditions at Oregon Inlet were not stable.

March 1

1975—Weather Personality Walks Home After Late-Night Broadcast

Charles M. Gertz, television weatherman and resident of Carova Beach just south of the Virginia/North Carolina border, had to walk home 15 miles after being stopped on his late-night commute following his 11:00 p.m. broadcast on WAVY-TV in Portsmouth, Virginia. Federal law enforcement officials denied Gertz access to cross a 4.2-mile stretch of beach on the Back Bay National Wildlife Refuge. Two days earlier, a court ruling had allowed for restricting beach access on the refuge, which was the most direct route to Virginia Beach for residents on the isolated Currituck Banks.

March 2

1994—State Board of Elections Overturns Write-In Decision

A write-in candidate for the Manteo Board of Commissioners was sworn in after the Dare County Board of Elections received a ruling from the State Board of Elections. The state decision overturned the local organization's judgment in a case that involved whether ballots should be counted for a write-in candidate if only a last name was written on the ballot. The Dare County Board of Elections had ruled that ballots with only a last name should not be counted. The last name of the candidate in question was Midgette, a very widespread surname in Dare. The case was then sent to the Court of Appeals, where a judge agreed with the county's original decision.

March 3

1893—Legislators Outlaw Sunday Fishing

The North Carolina General Assembly ratified an act making it illegal to fish in Dare County waters on Sunday using nets or by any other manner. Anyone found in violation of the new law would be guilty of a misdemeanor punishable by a twenty-five-dollar fine or incarceration for twenty days.

March 4

1961—Tar Heels Shine Bright at Cincinnati Show

The North Carolina delegation and exhibits reportedly "stole the show" the first day of the Ohio Valley Sports and Travel Show in Cincinnati. The exhibit featured a statewide display, sponsored by the Advertising Division of the North Carolina Department of Conservation and Development, along with displays by individual exhibitors. Nags Head's Carolinian Hotel hosted a booth that was manned, no doubt, by Outer Bankers in their traditional Dare Coast Pirate's Jamboree costumes. Tar Heels on hand to act as ambassadors included Governor Terry Sanford and Director of the Department of Conservation and Development Hargrave Bowles. A total of eighty North Carolinians represented the Old North State.

March 5

1728—North Carolina/Virginia Border Determined

Virginia statesman William Byrd II, aka William Byrd of Westover, arrived at Coratuck (Currituck) Inlet. Byrd was part of a delegation of officials and surveyors from Virginia and North Carolina who were working to survey the dividing line between the two colonies. While at the inlet, Byrd took time to note that "a vertuoso might divert himself here very well, in picking up Shells of various Hue and Figure, and amongst the rest, that Species of Conque Shell which the Indian Peak is made of." This is one of the earliest references to shelling along North Carolina's beaches.

March 6

1894—Presidential Hunting Trip Successful

President Grover Cleveland arrived back in Washington and appeared healthy, ruddy and bronzed after a nine-day hunting trip to North Carolina aboard the lighthouse tender *Violet*. Cleveland had surgery the year prior, which most likely explained his many recreational visits to the Outer Banks soon afterward. During his trip, the president toured the old Fort Raleigh site on Roanoke Island and visited Manteo. Cleveland also inspected the lighthouses and inlets of the region and met several islanders in the process. The hunting party returned with geese, duck, brant and swan, which were shared with the cabinet.

March 7

1962—Storm Called "Worst Ever" Strikes Dare Beaches

A combination of atmospheric conditions mixed to create a storm that brought high ocean tides and serious damage to the Outer Banks and the Atlantic coast. Severe ocean overwash occurred from Kitty Hawk to South Nags Head,

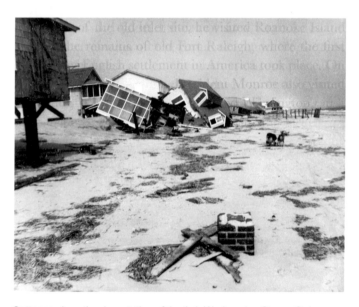

Cottages show the devastation of the Ash Wednesday Storm. *Outer Banks History Center Collections, 1962.*

stranding unsuspecting residents. Ephey Priest rescued people on his road grader, and Sam Beacham and Bill Quidley in Kitty Hawk used a motorboat to search from house to house for anyone who might need a lift out of the flood. On Hatteras Island, an inlet broke through north of Buxton. It was reported that Roanoke Island residents were unaware of conditions on the beaches. Aycock Brown, director of the Dare County Tourist Bureau, dubbed the tempest the Ash Wednesday Storm, as that was the day on which it fell. The community pulled together following the storm, and newspaper accounts from the spring of 1962 reported that the businesses were prepared to receive seasonal visitors.

March 8

1932—Deadly Nor'easter Leaves Mark on Coast

Thirty years prior to its monster-status cousin, the Ash Wednesday Storm, an equally ferocious tempest wreaked havoc on area beaches. The nor'easter of March 8, 1932, destroyed homes and disrupted the livelihoods of residents from Harker's Island to Duck. The area of Rodanthe was hit particularly hard when what was described as a six-foot wall of water washed over the village, sweeping homes from their foundations. Three inlets were cut between the sound and the ocean between the Pea Island Coast Guard Station and the tri-villages area. Fisherman endured the loss of both nets and boats. Traffic on the Wright Memorial Bridge was suspended because of damage to the approach to the span. Mail boats stayed in port, and the southern villages on Hatteras Island were out of communication for two days.

March 9

1891—New Light Shines in Pamlico Sound

The Pamlico Point Shoal Light was illuminated for the first time, and the 1889 temporary beacon nearby was extinguished. The screwpile lighthouse took twenty-three and a half days to construct and sat on wrought-iron pilings drilled eleven feet into the bottom of the sound. It replaced an old tower light built prior to the Civil War. The new hexagonal screwpile structure displayed a fixed white light emitted from a fourth-order Fresnel lens. In fog, the Pamlico Point Shoal Light put out an audible signal at ten-second intervals. This wooden lighthouse served at the entrance of the Pamlico River until it was deactivated and replaced with a modern lighting apparatus.

March 10

1952—Carteret Fishermen Make Big Haul in Dare Waters

A small group of fishermen from the waterside hamlet of Sea Level made an impressive catch of shad and herring in Long Shoal River off the Pamlico Sound. The catch was made in a short haul seine net and was taken to Deep Creek, an area just south of Stumpy Point, for unloading. It weighed more than a ton and was sold for $1,000, much to the satisfaction of the fishermen. Also in the catch was a thirty-pound rockfish that was full of roe. The men made the nine-and-a-half-hour boat trip to Dare because fishing was slow in Carteret.

March 11

1896—Lifesavers House Fishermen During Deluge

Seven soaking-wet fishermen showed up at the Kitty Hawk Life-Saving Station after seeking refuge in Kitty Hawk Bay because of inclement weather. The fishermen were taken in and given dry clothing to wear from a supply provided by the Women's National Relief Association for such purposes. While their garments dried out, the fishermen shared a meal and then spent the night at the station. The following day, the weather subsided to the point where the men could make it back to their camp.

March 12

2011—Record Tuna Brought to Oregon Inlet

Cory Schultz, fishing on the *Sea Breeze* with Captain Ned Ashby out of the Oregon Inlet Fishing Center, landed an 805-pound blue fin tuna, which became a new state record. It took the Waverly, Virginia angler two and a half hours to bring the behemoth to the boat. The catch was certified four days later. It topped a 744-pound tuna that was caught in 1995. For those interested in seeing how large an 800-pound tuna is, a cast model of the state-record fish now hangs in the parking lot of the Oregon Inlet Fishing Center.

March 13

1969—Russian Vessel Lost After Ships Collide at Sea

A predawn collision between a nearly 700-foot Panamanian tanker bound for Aruba and a 125-foot Russian trawler that was part of a large fishing fleet took place thirty-one miles off Oregon Inlet. The Soviet vessel sank with the entire crew, estimated to be between twenty-two and twenty-five men. The Coast Guard sent two aircraft and a forty-four-foot boat in response, which reported finding an oil slick, debris and an empty life raft. The tanker *Esso Honduras* stayed on the scene five hours and aided in the search. No one aboard the tanker was reported injured.

March 14

1967—Fishing Nets Snare Large Bomb

The trawler *Crisway*, fishing with a crew of twelve forty miles off Cape Hatteras, made a potentially deadly catch when it snagged a five-hundred-pound bomb in its fishing nets. Although initial plans were to deactivate the bomb, after a four-hour inspection by navy officials, the four-foot explosive device was declared unsafe for defusing. It was towed farther out to sea and cut from the fishing net by navy explosive experts. The ordnance was thought to have been dropped by an airplane. Tension was high on the fishing vessel as the crew remained on board for the thirty-hour ordeal.

March 15

1991—Patriotic Ribbon Tied around Cape Hatteras Lighthouse

In preparation for Operation Standing Watch, a ceremony to honor military personnel serving in the Persian Gulf region and Hatteras Island's contributions to the war, the Cape Hatteras Lighthouse was decorated with a red, white and blue ribbon. The 3-foot-wide, 120-foot ribbon was affixed to the tower by workers who were renovating the 1870 structure. The ceremony, held the following day, featured a flyover by navy F-14 Tomcats. Over one thousand people attended to show support for the troops. During the ceremony, the ribbon was dedicated to the soldiers serving in Operation Desert Storm.

March 16

1966—Sleeping with the Fishes

A man's decomposing body washed ashore at Kitty Hawk with its legs and torso wrapped in chains. Dare County sheriff Frank Cahoon said he didn't believe the body was that of a local person or someone off a merchant ship or fishing trawler. The Coast Guard hadn't received any missing persons reports. The body was later determined to be that of fifty-nine-year-old William Wright Johnson, a Norfolk salesman who had been missing for over three months. Sheriff Cahoon and Norfolk Police chief Harold Anderson (the author's grandfather) agreed that a thorough investigation would be performed.

March 17

1973—Hundreds Attend Fishing Hearing

Manteo High School Auditorium was filled with over four hundred people for a hearing hosted by a special task force charged with finding means for a peaceful coexistence between commercial and recreational fishermen within the boundaries of the Cape Hatteras National Seashore. The creation of the task force was sparked after a group of recreational fishermen, who were catching fish with rods and reels, had the school of fish into which they were casting netted by commercial fishermen before their eyes. Recommendations of the task force included educating the public about the heritage of commercial fishing on the Outer Banks, licensing commercial fishermen who would fish within park limits (issued to residents only) and an aggressive public education program informing park users of their rights, privileges and responsibilities.

March 18

1990—Nags Head Spring Tradition Born

Bill Shaver throws candy to the crowd in the first Kelly's Outer Banks St. Patrick's Day Parade. *Drew C. Wilson Collection, Outer Banks History Center, 1990.*

Kelly's Outer Banks Restaurant and Tavern and Beach 95-FM teamed up for the first St. Patrick's Day parade in Nags Head. Beach-95 assembled a kazoo band, led by indomitable station manager Pat Cahill. Fire stations from beach municipalities, veterans groups and floats that promoted the St. Patrick's Day theme were part of the colorful procession. The event grew in popularity over the years and is now a tradition and rite of spring. Restaurateur Mike Kelly dubbed it the biggest St. Patrick's Day parade in the state and has yet to be challenged.

March 19

2002—Outer Banks Hospital Opens Doors

A milestone in Outer Banks healthcare was reached when the Outer Banks Hospital opened for business at 4:00 a.m. It wasn't long before the first patient was treated an hour and a half later and then transferred to critical care in Norfolk. The first person admitted to the nineteen-bed, 82,400-foot facility was a young woman from Grandy, North Carolina, who gave birth to an eight-pound, eight-ounce boy shortly before midnight. The second baby born at the hospital came less than twelve hours later. Outer Banks Hospital saw fifty-nine patients in its first twenty-four hours of operation, took in three patients and performed eight outpatient services.

March 20

2003—Historic Hunt Club Up in Flames

The Currituck Shooting Club clubhouse caught fire and quickly burned on a windy evening. Lost in the blaze were antique guns, photographs and decoys. By the time firefighters arrived, flames were already licking through the roof of the wooden structure. With no hydrants in the area, firefighters pumped water from the Currituck Sound to contain the fire. In a stroke of good fortune, the club's leather-bound record books were in Greensboro, North Carolina, undergoing conservation work and, as a result, were spared. While the clubhouse that burned was built in 1879, the club itself predates the Civil War.

March 21

1973—David Stick Addresses Realtors

Noted author and historian David Stick was the guest speaker at the regular monthly meeting of the Dare County Board of Realtors at the Elizabethan Restaurant in Manteo. Stick, a member of the organization, was the first licensed real estate broker in Dare County. In his speech, "The Realtor's Role in the Future of the Outer Banks," he suggested that perhaps changes initiated by progress and growth were undermining what attracted people to the Outer Banks in the first place. His words attracted much attention both on the Outer Banks and beyond. The Dare County Board of Realtors responded by forming a committee to establish "proper and practical plans" for moving into the future.

March 22

1990—Inlet Group Seeks Preservation of Coast Guard Station

At a meeting of the Oregon Inlet and Waterways Commission, a motion was passed asking the Dare County Board of Commissioners to introduce a resolution asking for a reprieve for the old Oregon Inlet Coast Guard Station on the north end of Hatteras Island. The commission believed that the old, abandoned station, built in 1897, would continue to be useful even if only as a manned outpost since it was closer to the inlet than the new Station Oregon Inlet that was under construction on the inlet's north shore.

March 23

1958—Flu Epidemic Hits Ocracoke

Dr. Garland Wampler, U.S. Public Health Service doctor from Hatteras, visited Ocracoke Island to assist Kathleen Bragg, the island's only registered nurse. Bragg, along with 60 percent of the island's five hundred residents, was in bed with the flu and suffering from nausea and cramps. Some of the sick had temperatures as high as 105 degrees. Dr. J.W.R. Norton, state health officer in Raleigh, ordered medicine rushed to Ocracoke from Beaufort by a Coast Guard helicopter. Following the doctor's visit and the influx of medicine, Nurse Bragg reported that the epidemic, which lasted over a week, was under control. While antibiotics were given in the worst of cases, most islanders toughed it out with aspirin and cough medicine.

March 24

1945—Large Haul of Croakers Taken at Colington

Eighty thousand pounds of croaker were netted by J.H. Haywood of Colington while he was fishing between Colington Island and the Wright Memorial Bridge. The fisherman enlisted the help of Kitty Hawk's Dan Baum to help haul in the record catch. By the following morning, fish dealers began to show up ready to purchase the fish, which averaged between one and one and a half pounds. It was reported that over half the catch was purchased by local fish wholesaler D.D. Whitson at ten cents a pound. The massive catch filled eight hundred boxes and was sold for over $8,000.

March 25

1995—Corolla's Ponies Rounded Up

The famed wild horses of Currituck Banks were herded up by volunteers on horseback and in four-wheel-drive vehicles and corralled north to a fenced-off, undeveloped area. Twenty of the twenty-six stout and shaggy banker ponies were moved to their new home, which was hoped would be a safer environment than the busy tourist resort. Many Corolla horses were struck by cars after the road to Currituck Banks opened in 1984. To make matters worse, development of the area introduced landscaped yards and lawns, a treat to eat for the shaggy ponies. The move was seen as necessary in order to preserve the wild herd for another four hundred years.

March 26

1974—Foreign Fishing Boat Too Close to American Shore

The U.S. Coast Guard took the Romanian fishing trawler *Inau* into custody eight and a half miles off Currituck Beach for fishing three and a half miles inside U.S. territorial waters. It was the second Eastern European fishing boat discovered that year fishing inside the twelve-mile territorial limit. The 290-foot *Inau* and its crew of eighty-four were escorted to Baltimore by the U.S. Coast Guard cutter *Unimak*. It was carrying twenty tons of mackerel and river herring. While in Baltimore awaiting trial, the crew members were first confined to their vessel but were eventually allowed ashore. Five weeks later, the Romanian government paid a $100,000 civil penalty for the release of the *Inau*.

March 27

1986—Elizabeth II *Runs Aground in Roanoke Sound*

On its return trip from haul out at Wanchese, where it received a fresh coat of paint, the representative sailing ship *Elizabeth II* ran aground on a shoal in the channel between Wanchese and Manteo. The vessel was stuck for about twenty minutes, just south of the Washington Baum Bridge. The *Elizabeth II* was being moved with the assistance of the tugboat *Albemarle* and was not damaged during the brief incident. The two-and-a-half-year-old ship berthed at Ice Plant Island later that day. Captain Horace Whitfield admitted that sometimes the ship bumped the bottom, but this was the first time it got stuck.

March 28

1967—Ocean Flyers Parachute from Failing Plane

Two naval aviators parachuted to safety after the aircraft they were flying had problems with its engine. The men were based at Naval Air Station Oceana in Virginia Beach and were flying on a mission to the Dare bombing range on the mainland. After the pilot and bombardier ejected from the aircraft, it crashed in the ocean a half mile offshore, near the Oregon Inlet campground. The men landed safely near the Pea Island Refuge office and were rescued by helicopter. One was returned to Oceana, and the other was flown to Coast Guard Base Elizabeth City due to an injury to the ankle. Since the airplane was in shallow water and was assumed to have stayed intact, it was hoped that it could be salvaged.

March 29

1939—Agreement Reached between
Park Service and Colony

A formal agreement was signed by D. Bradford Fearing, president of the Roanoke Island Historical Association, and Oscar L. Chapman, assistant secretary of the interior. The memorandum of cooperation gave ownership of the Fort Raleigh historic site to the National Park Service while at the same time allowed for the historical association to continue presenting *The Lost Colony* at Waterside Theater each summer. It would be two more years before Fort Raleigh National Historic Site was formally established under the National Historic Sites Act. Following the 1941 season of *The Lost Colony*, a four-year hiatus began as America became involved in World War II.

March 30

1948—Sought-After Whale Heads to Virginia

After it floated in the ocean off the Virginia-Carolina coast for over a week, representatives from the Norfolk Tallow Company worked to remove a forty-five-foot whale carcass from the beach at Kill Devil Hills. The dead whale, which the Coast Guard believed was struck by a ship, had drawn the attention of many boats that were eyeing the fat the sea mammal would render. It finally washed ashore near the Wright Brothers Memorial.

March 31

1987—Tornado Flies Under Radar

An early morning tornado struck the Hatteras Island village of Buxton, scattering boats, tossing vehicles and damaging homes. Two people were injured when their mobile home imploded in the twister. The funnel cloud then skipped to Avon to continue its destruction. Winds were estimated

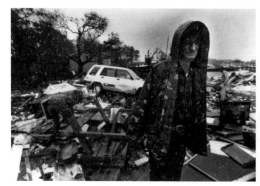

Trucks were overturned and trailers destroyed by the Buxton tornado. *Drew C. Wilson Collection, Outer Banks History Center, 1987.*

to be at least one hundred miles per hour. Damage to the Buxton Harbor area was estimated at $200,000. No watches or warnings were issued because the storm formed so close to the National Weather Service office at Cape Hatteras that the tornado was not detected on radar. A street in Buxton near where the twister touched down is now known as Tornado Way.

April 1

1943—Suspicious Fire Burns Wharf, Strands Mainlanders

The ferry terminal on Roanoke Island's north end burned in a blaze that was described as "mysterious" and most likely "of malicious origin." The nine-hundred-foot wharf was the spot where the ferry connecting Roanoke Island and Manns Harbor took on and discharged vehicles. The interruption of ferry service came at a particularly bad time because mainland fishermen used the ferry to send fish to Manteo to be shipped to Norfolk. Mail and other freight were also transported on the ferry. Additionally, ferry service across the Alligator River connecting mainland Dare with Tyrrell County had been suspended. Captain Thomas A. Baum, owner of the ferry, labored with state highway workers and rebuilt the wharf. They had the ferry running in a week's time.

April 2

1863—Nor'easter Claims Navy's First Sub Off Hatteras

The USS *Sumpter* was en route to Charleston, South Carolina, to participate in a Union naval attack on that city. *Sumpter* was towing the navy's first submarine, the forty-seven-foot *Alligator*. The vessels suffered the same fate as many others when they encountered a nor'easter off Cape Hatteras. The *Sumpter*'s captain was faced with a difficult decision, but in order to save the *Sumpter*, Captain J.F. Winchester cut the *Alligator* adrift. It was reported lost at sea. The *Alligator*, built in Philadelphia in 1861, was originally powered by oars but was later fitted with a hand-cranked propeller. It was designed by Frenchman Brutus de Villeroi, whose occupation on the 1860 census of the United States was listed as "natural genius." As of yet, underwater archaeologists have not located the notable submarine.

April 3

1965—Nags Head Delegation Wants Better Representation

A group of Nags Head citizens and business leaders met with two county commissioners at the Dare County Courthouse to present a petition requesting the creation of an additional township in the county. Nags Headers were frustrated that their small numbers did not allow them to elect a commissioner from the town onto the county board or board of education. Nags Head and Manteo were both in the Nags Head Township that was made up of a majority of the population and taxable property in Dare County. Dare County at that time had five county commissioners: one from Nags Head and Roanoke Island; one from each of the two townships on Hatteras Island; one from Atlantic Township that represented Duck, Colington and Kill Devil Hills; and one from the mainland. Today, seven commissioners represent the county: two from Roanoke Island and the mainland; two from Nags Head, Kill Devil Hills and Colington; one from Hatteras; and one from Kitty Hawk, Southern Shores and Duck. There is also an at-large delegate who can come from any district. Commissioners are elected countywide for these seats.

April 4

1988—Traffic Stopped After Dredge Touches Bridge

The dredge *Schweizer*, tasked with dredging sand at Oregon Inlet, had its hull punctured after it came down hard when a swell passed through the inlet. A large gash in the dredge's side caused it to take on water, and consequently, *Schweizer* lost most of its steering capability. The dredge lightly bumped the Herbert C. Bonner Bridge, causing the captain to purposely ground the vessel to prevent any additional damage. Traffic on the bridge was stopped for two hours while inspectors from the North Carolina Department of Transportation checked the twenty-five-year-old structure for any possible damage. Finding none, the span was reopened. *Schweizer* was scheduled to be replaced on April 15 by the dredge *Merritt* but headed to dry dock a few days ahead of schedule.

April 5

1961—Sea Hag *Is Christened and Sent to Raleigh*

The representative pirate ship *Sea Hag*, built as an ambassador vessel for junketeers promoting the Dare Coast Pirate's Jamboree, was christened on Kitty Hawk Beach. The twenty-eight-foot wooden structure was mounted on an automobile chassis and, just after it was christened, began a road trip to Raleigh. The following day, a group of Dare Coast pirates climbed aboard the *Sea Hag* at the state capitol building and issued Governor Terry Sanford an invitation to the Dare Coast Pirate's Jamboree to be held at the end of April. During the trip, the Dare pirate delegates also visited the General Assembly, were filmed for a television show, had dinner at Cameron Village and appeared on the town common in Tarboro, North Carolina. The jamboree was a multi-day event created to kick off the vacation season. It attracted a pre-summer crowd to the area.

April 6

1954—Senate Candidate Visits Manteo, Vows to Improve Inlet

Former North Carolina governor and candidate for the U.S. Senate W. Kerr Scott spoke at a meeting of the Manteo Lions Club and, during his "stump speech," advocated using federal funds to keep Oregon Inlet open. The Alamance County native considered himself a "transportation-minded man" and believed that keeping Oregon Inlet navigable would aid in the transportation needs of the country. The Democratic contender for Congress also praised the country church, to which two-thirds of North Carolinians belonged. Prior to his speech, Scott spent the day traveling around Dare County. He won the Senate seat that November, defeating Republican candidate Paul C. West. Scott served until his death in 1958.

April 7

1819—Chief Executive Visits, Views Fort and Inlet

U.S. president James Monroe visited the site of the recently closed Roanoke Inlet, south of Jockey's Ridge and adjacent sand dunes. With the inlet's closing, northeastern North Carolina no longer had a navigable waterway to the Atlantic Ocean, which was needed for the economic growth of the Albemarle region. After the president's inspection of the old inlet site, he visited Roanoke Island to view the remains of old Fort Raleigh, where the first attempts at English settlement in America took place. On this trip to North Carolina, President Monroe also visited Plymouth, Washington, New Bern and Wilmington.

April 8

1987—Inlet Reopens, If Only for a Week

After being closed for almost a month due to dangerous conditions, the Coast Guard reopened Oregon Inlet for daylight use only. Local fishermen, who relied on the passageway to the Atlantic Ocean, especially during the winter fishing season, were relieved, and three Wanchese-based trawlers entered the inlet as soon as it opened. A new ten-foot channel was created and marked with unlighted buoys; however, a storm and heavy seas a week later washed the temporary buoys away, and the inlet was closed again. Losses to the fishing industry were estimated at $12 million while the inlet was closed.

April 9

1942—U-Boat Sinks British Merchant Vessel

The British tanker *San Delfino* became another victim of *Paukenschlag* or Drumbeat (German admiral Karl Donitz's plan of sinking Allied merchant ships along the Atlantic coast) when it was torpedoed off Cape Hatteras by the German *U-203*. Twenty-four crewmen and four gunners lost their lives in the attack. A body washed ashore on Hatteras Island a month after the sinking and was buried north of the Cape Hatteras Coast Guard Station. It was later identified as Michael Cairns of the Royal Merchant Navy. Another body that was never identified but assumed to have been from the *San Delfino* was recovered two weeks later and buried next to Cairns. The graves were maintained by coastguardsmen for many years, but after their retirement, the sites became overgrown and practically forgotten. In the early 1990s, the Graveyard of the Atlantic Museum took action to clear and recognize the British graves.

April 10

1943—Aviator Killed in Roanoke Sound Crash

A young pilot was lost when Ensign William E. Schlueter's airplane, flying out of the Navy Landing Field north of Manteo, crashed into Roanoke Sound. Schlueter, of Tulsa, Oklahoma, was attached to the aircraft carrier USS *Battle of Bunker Hill* at the time of his death. His parents created a fellowship in chemistry at Oklahoma University in their son's memory. Both Schlueter and William Duboise Burnham, a twenty-two-year-old naval aviator who lost his life on April 1, were remembered at a memorial service at Mount Olivet Methodist Church in Manteo.

April 11

1952—Governors Skunked on Inshore Fishing Trip

Following a meeting of the Raleigh Executives Club, North Carolina governor W. Kerr Scott took Arkansas governor Sid McMath on a fishing trip to Oregon Inlet. The chief executives, along with Scott's secretary and several reporters, flew from Raleigh to Manteo on a Boeing C-17. The governors fished aboard a private boat captained by Sam and Omie Tillett. The newspapermen toured the inlet aboard the North Carolina State Fisheries vessel *Croatan*, captained by Thomas Basnight. Although the party was seeking channel bass, the fish did not cooperate. Governor Scott and his entourage returned to Raleigh that afternoon.

April 12

1939—Dare Sheriff Hitches Ride in Plane

Newspapers across America ran a wire story involving Dare County sheriff D. Victor Meekins. According to the wire report, Meekins was "forty miles out in the sand dunes" when his car gave out, and he thumbed a ride in an airplane that was passing overhead. Most likely, the pilot who aided Meekins was Dave Driskill, the National Park Service pilot responsible for delivering supplies to the Works Progress Administration projects along the Dare County beaches.

April 13

1987—Bronze Busts of Wrights Go Missing

A worker at the Wright Brothers Memorial noticed that the bronze busts of Orville and Wilbur Wright were gone, but since there was no damage to the pedestals on which the busts rested, the Park Service employee assumed they had been removed for maintenance in preparation for a fly-in scheduled to coincide with the celebration of Wilbur Wright's birthday. The busts were reported missing the following day. The bronze sculptures were a gift to the park in 1960, and at that time, they were valued between $5,000 and $6,000. It was the second time in two years that the statues, weighing between thirty and forty pounds each, had been stolen.

April 14

1912—Titanic's SOS Call Heard at Hatteras Weather Station

Richard Dailey, while working at the Hatteras Weather Bureau Station in Hatteras Village, received a distress call from the ill-fated ocean liner *Titanic*. At 11:25 p.m., a message came in via wireless telegraph, "CQD," a radio signal meaning "All Stations: Distress," which was followed by the ship's coordinates. Ten minutes later, at 11:35 p.m., a new set of coordinates was sent from the *Titanic* with the message, "Have struck iceberg." The Marconi Station at Cape Race, Newfoundland, Canada, also received the message and dispatched the ship *Carpathia* to assist the *Titanic*.

April 15

1858—New Screwpile Light Shines at Roanoke Marshes

The lamp was lit for the first time in the fourth-order Fresnel lens of the Roanoke Marshes Light. The hexagonal structure, which sat on seven pilings, was the second light in Croatan Sound to bear the name Roanoke Marshes. It replaced an earlier light in the same vicinity put in operation in 1831. After enduring damage from the elements, the 1858 light was superseded by a third Roanoke Marshes light that operated between 1877 and 1955. A historic reproduction of the third lighthouse was built on the Manteo waterfront and was dedicated on a perfect fall day in September 2004.

April 16

1905—New Baptist Congregation Organized in Manteo

Twenty-five people met at the Dare County Courthouse for the purpose of organizing a new congregation, Manteo Baptist Church. Although there was already a Baptist church on the island, Roanoke Island Baptist Church, it was four miles from the town of Manteo and a long trip when traveling in an ox cart. The original Manteo Baptist Church building was a wooden structure that was followed by the brick building used today. In 1909, a dozen congregants of Roanoke Island Baptist Church were dismissed to form Nags Head Baptist Church. All three congregations remain active.

April 17

1988—Man Ends Bridge Vigil

Dan Lawrence unchained himself from the Oregon Inlet Bridge after a three-day combination protest and hunger strike. Following a severe storm, Lawrence, a Hatteras Island resident, business owner and candidate for the North Carolina Senate, secured himself to the bridge to draw attention to the need for a reliable route to Hatteras Island after the base of the Oregon Inlet Bridge suffered erosion. During his time on the bridge, the forty-two-year-old subsisted on a liquid diet. He became concerned for his safety after he received threatening comments from two men who drove by. In addition to abandoning his protest, Lawrence also gave up his run for the North Carolina Senate seat.

Dan Lawrence held a vigil to draw attention to the deteriorating conditions of the Herbert C. Bonner Bridge across Oregon Inlet. *Drew C. Wilson Collection, Outer Banks History Center, 1988.*

April 18

1939—Stealth Wright Sneaks Peek at Memorial

Orville Wright, who asked that his visit remain a secret until his departure, drove down to Dare County to see the site of his famous first flight near the Wright Memorial. Old local friends Captain William Tate, formerly of Kitty Hawk but now stationed at the Coinjock Lighthouse Depot, and Alpheus Drinkwater of Manteo accompanied the aviation pioneer during his brief visit. Wright, who squeezed in his trip to Kitty Hawk between two meetings in Washington, D.C., traveled to Kill Devil Hills with aviation reporter and editor Earl N. Findley.

April 19

1944—Navy Recruiter in Manteo

With the United States fully engaged in World War II, J.W. Brown, chief petty officer at the U.S. Navy recruiting station in Elizabeth City, visited the Manteo Post Office with the hope of signing young men and women up for service. Seventeen-year-old young men who volunteered were given the option of choosing to train for service in the Navy Medical Corps, the Navy Air Corps, as a radio technician or for general service. Healthy women between twenty and thirty-six years old could enlist in the WAVES, an acronym for Women Accepted for Volunteer Emergency Service. Brown strongly encouraged anyone with interest to speak with him before he left for duty at the end of the month.

April 20

1936—Nets Filled at Nags Head

In an afternoon haul, Captain Mervin Saunders and his beach seine crew loaded their nets with over six hundred pounds of rockfish and salmon trout. The group was fishing from the beach near the Nags Header Hotel. The water was described as "alive with fish" that were chasing minnows close to shore. It was one of the first big catches of the fishing season. Herbert Perry, a fish dealer from Kitty Hawk, purchased the fish for ten cents a pound. Although the term is not frequently used along the Outer Banks, *salmon trout* are any type of large trout fish.

April 21

1999—Two Rare Turtles Given Lift to Gulf Stream

After rehabbing at the North Carolina Aquarium on Roanoke Island for a month, two Kemps Ridley sea turtles were taken via Coast Guard vessel to the warm waters of the Gulf Stream. The pair was found washed ashore and cold-stunned on Hatteras Island. It was the first reported rescue of the endangered Kemps Ridley turtle on the Outer Banks. The turtles were taken to Coast Guard Station Hatteras Inlet by members of NEST, the Network for Endangered Sea Turtles, and a NEST volunteer also accompanied the sea creatures on their ride to warmer waters about a dozen miles out of Hatteras Inlet. The turtles reportedly became more active during their boat ride. The release went well.

April 22

1959—Grounded Liberty Ship Floated

The 445-foot liberty ship *Antonin Dvorak*, which ran ashore near the Little Kinnakeet Coast Guard Station four weeks earlier, was pulled off the beach at Kinnakeet. A salvage tug took advantage of the day's favorable tide and weather. The ship, which had been sold for scrap iron, went ashore while being towed to Baltimore's Bethlehem Steel Company scrap yards. Hatteras Island merchants enjoyed an upswing in business while the *Dvorak* was aground because sightseers flocked to get a look at the stranded vessel. Many business owners wished that the ship would remain beached.

April 23

1982—Travelers Routed South, Coinjock Bridge Out of Commission

The small swing-span bridge across the Chesapeake and Albemarle Canal (a portion of the Intracoastal Waterway) at Coinjock was unable to close after it was hit by a barge while in the open position. The bridge was subsequently closed to traffic. The Coast Guard and the state provided boats for ambulance passengers and travelers on foot. Those driving to the beaches needed to take a ninety-mile detour down U.S. 17 south to NC 32, across the Albemarle Sound near Edenton and then west on U.S. 64. Tourism officials were concerned with Outer Banks vacationers traveling to and from the beach for the weekend. Although it was estimated that repairs would take between seven and ten days, the bridge opened two days later.

April 24

1958—National Seashore Becomes Reality

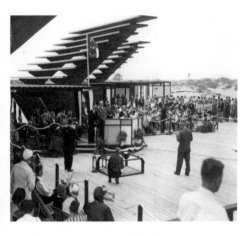

Congressman Herbert C. Bonner gives remarks at the dedication of the Cape Hatteras National Seashore. *National Park Service photo, 1958.*

The Cape Hatteras National Seashore, the country's first national seashore park, was dedicated. The celebration kicked off at the Cape Hatteras Lighthouse with the dedication of a plaque recognizing the gift of 2,700 acres of land to the national seashore by the descendants of the park's first donor, Henry Phipps. The afternoon portion of the event took place at the Coquina Beach day-use area with its eye-catching picnic shelters. The culmination of the day was the mingling of the waters, when eminentoes poured water from Old Faithful (representing Yosemite, the first national park) and the Atlantic Ocean (representing Cape Hatteras, the first national seashore). The event coincided with the kickoff of the fourth-annual Dare Coast Pirate's Jamboree. The day's activities ended with the Jamboree Coronation Ball.

April 25

1957—Mainland Link to Roanoke Island Dedicated

The three-mile William B. Umstead Bridge connecting Roanoke Island's north end with Manns Harbor was dedicated. The span across the Croatan Sound bore the name of North Carolina's sixty-third governor, who died in office in 1954 after serving only two years. His wife and daughter were on hand for the event, which took place under sunny skies. Miss

Dignitaries assemble for the dedication of the William B. Umstead Bridge. *Aycock Brown Collection, Outer Banks History Center, 1957.*

Merle Bradley Umstead unveiled a memorial plaque at the east entrance to the bridge, and Mrs. Merle Umstead cut the ribbon. Five high school bands were present to add to the day's festivities: Elizabeth City, Plymouth, Williamston, "little" Washington and Currituck's Griggs High School.

April 26

1902—Wireless Experiments on Island's North End

Radio pioneer Reginald A. Fessenden continued his experiments in wireless telegraphy sending messages between his stations on Roanoke Island's north end and on Hatteras Island near Buxton. The Canadian inventor, working as a special agent of the U.S. Weather Bureau, was observed by officials of the U.S. Army Signal Corps, U.S. Coast and Geodetic Survey and the U.S. Navy. Messages were sent at a rate of thirty words per minute, but Fessenden said that with a trained professional, as many as fifty to seventy words per minute could be sent. Other findings showed that much more energy was needed to transmit messages over brackish water than salt water. Fessenden lived in Manteo for two years while advancing his wireless system.

April 27

1997—Marker Dedicated to Civil Air Patrol

A memorial was unveiled at the Dare County Regional Airport honoring the men and women of the Civil Air Patrol (CAP) who served at CAP Base 16 at that site during World War II. The inscribed granite tablet bore the names of the men and women who were stationed at Base 16. The CAP was made up of civilian pilots who flew missions to aid in convoy duty and to act as lookouts for German U-boats that were lurking offshore and menacing merchant ships. Other administrative and ground personnel rounded out the war effort. Especially poignant was the recognition of two pilots, Frank M. Cook and Julian L. Cooper, who lost their lives flying on a CAP mission.

April 28

1959—Dare Hospitality Shown to Travel Group

A group of travel writers and car club managers from over fifteen states arrived on the Outer Banks on a tour of eastern North Carolina. Their Trailways bus first stopped at the Sea Ranch Motel in Southern Shores as guests of owners Buck and Alice Sykes. After some mid-morning refreshments, they headed to the Wright Brothers Memorial and on to a buffet lunch as guests of George Crocker at his Beacon Motor Lodge in Nags Head. During the afternoon, the out-of-towners visited Coquina Beach, the Bodie Island Lighthouse, Fort Raleigh and the Elizabethan Gardens. Evening activities and a banquet were hosted by the Carolinian Hotel. The group overnighted at the Beacon. The following morning, rain prevented an Oregon Inlet fishing trip, so the group went on to tour Hatteras Island.

April 29

1956—Governor and Wife Wrap Up Weekend on Coast

North Carolina governor Luther H. Hodges and first lady Martha B. Hodges were in Corolla after being honored guests at the second-annual Dare Coast Pirates Jamboree. While on the Currituck Banks, Hodges viewed beach erosion and sand fixation projects of the North Carolina Wildlife Resources Commission, created to keep ocean water out of the Currituck Sound, and a forest restoration project initiated by Ray Adams of the Whalehead Club. The governor remarked that the planting of thousands of seedlings along the sands of Currituck Beach was "one of the finest tree planting programs in North Carolina, or the finest I have seen to date."

April 30

1966—Outdoor Pressmen Convene in Nags Head

A newly formed organization, the Tarheel Outdoor Press Association, met at Nags Head's Carolinian Hotel. Made up of outdoor writers, columnists and broadcasters, the group was "noted for their collective inability to catch fish." During their weekend gathering, approximately twenty attendees enjoyed a banquet that featured speeches by Art Smith of the *New York Herald* and Dr. Fred Barkalow from North Carolina State University. Representing locally was publicist Aycock Brown, director of the Dare County Tourist Bureau, who received a special "Bullfish Fisherman" award that was arranged by Rod Amundson of the North Carolina Wildlife Resources Commission.

May 1

A one-act play written by Catherine Meekins, a local woman of many talents, premiered in the Manteo High School Auditorium. It was presented by the Elizabethan Players of the Roanoke Island Drama League, of which Meekins was a member. The play, set in Nags Head, depicted the challenges following the severe hurricane of August 1933. Howard Twine and Velma Sanderlin (two promising members of the league) played the leading roles. Meekins's work was vetted by New York's Union Theater Board, which praised the play for its "stark realism and good dramatic qualities."

MAY

May 2

1964—Herbert C. Bonner Bridge Ribbon Cutting

Although it had been opened to traffic for several months, the Herbert C. Bonner Bridge connecting Bodie Island and Hatteras Island was officially dedicated. The two-and-a-half-mile, $1.5 million span over Oregon Inlet made Hatteras Island more accessible. On hand for the festivities were North Carolina governor Terry Sanford, former governor and U.S. secretary of commerce Luther Hodges and the bridge's namesake, Congressman Herbert C. Bonner. The ribbon was cut by Nora C. Herbert of Hatteras Island and Roanoke Island's Catherine Meekins, widow of newspaper publisher and former Dare County sheriff D. Victor Meekins.

May 3

1986—Descendants and Guests Celebrate Renovation

Three hundred people braved chilly temperatures and characteristic spring winds to attend a reopening ceremony for the double keepers' quarters at the Cape Hatteras Lighthouse. The structure, built in the 1850s, served as a duplex that housed two assistant keepers' families side by side. The ribbon cutting and reopening followed a three-year renovation project. Photographs from the 1890s were used to aid in the appearance of the building's exterior. The interior reflected the look of the structure in the 1930s, when work by the Civilian Conservation Corps added cypress paneling. Many of the attendees at the day's event were descendants of Cape Hatteras Lighthouse keepers.

May 4

1950—Birth of a Beauty Queen

Hatteras Island's Lila Peele was popular with pageant judges and local photographers. *Outer Banks History Center Collections, circa 1949.*

Seventeen-year-old Lila Peele returned home to Hatteras after a whirlwind week of winning beauty contests. To begin, Peele was chosen as Miss Hatteras to represent her hometown village in the Miss Dare County pageant in Manteo. After clinching first place in the countywide contest, the attractive brunette went on to Elizabeth City to compete with other girls from the Albemarle region in a pageant to select the queen of the annual Potato Festival. Peele placed second and reigned as a maid of honor at the spudly festivities. Later that month, Peele's photograph was splashed across newspapers nationwide posing on a Hatteras Island beach holding a whelk egg case.

May 5

1996—Outer Banks Community Foundation Awards Founder

Author, historian and community activist David Stick was honored by the Outer Banks Community Foundation when he received the first ever Meritorious Award at a special dinner meeting at the Ramada Inn in Kill Devil Hills. The event hosted about 150 well wishers at $100 a plate. Stick moved to the Outer Banks with his parents, Frank and Maud Stick, in the late 1920s and embraced the history and culture of his adopted home. During the 1950s, he wrote two important works about the area: *Graveyard of the Atlantic* and *The Outer Banks of North Carolina, 1584–1952.* He became a mentor to a generation of new historians. Stick brought together actor Andy Griffith, entrepreneurs George Crocker and Edward Green, banker Ray White and lawyer Martin Kellogg to found the Outer Banks Community Foundation in 1982.

May 6

1983—Woman Sets Ultra-Light Record Flying to Kill Devil Hills

Jo Anderson became the first woman to fly cross-country in an ultra-light aircraft. The thirty-six-year-old Colorado aviatrix flew her 250-pound ultra-light plane from San Diego to Kill Devil Hills and landed at the First Flight Airstrip adjacent to the Wright Brothers Memorial. During her cross-country venture, a truck driving the ground route carried clothing, tools and additional supplies. Although foul weather—including blizzards, rain, high winds and a tornado—caused her to stay grounded more than planned, Anderson logged close to three thousand miles and eighty flying hours.

May 7

1981—Oil Slick Washes Ashore After Ships Collide

Following the collision of the 470-foot Greek freighter *Hellenic Carrier* and the 820-foot U.S. barge carrier *Lash Atlantico*, a seventeen-mile oil slick washed ashore from Nags Head to Oregon Inlet. The worst area of the spill was concentrated in the Coquina Beach area with slicks as large as fifty feet long by fifteen feet wide. The owners of *Hellenic Carrier* hired International Marine Services, Inc., to clean up the three-thousand-gallon spill. The U.S. Coast Guard and volunteers (some of whom were on vacation) aided in cleaning area beaches. The price tag for the cleanup was estimated at $500,000.

May 8

2004—Latvian Ship Remembered

A ceremony to honor merchant seamen for their service during World War II was held in South Nags Head. Of special recognition was the freighter *Ciltvaria*. The ship was sunk off the coast of North Carolina on January 19, 1942, by a torpedo launched from the German submarine *U-123*. In 1940, the *Ciltvaria* was one of eight merchant vessels that sailed under the flag of Latvia and refused a Soviet order to return to port and sail under the symbol of the hammer and sickle after Latvia was invaded. The story of the Latvian seamen was largely forgotten, until a journalist sixty years later wrote about the *Ciltvaria* in a Latvian newspaper and coordinated with the local *Outer Banks Sentinel* to arrange memorial services. The ceremony was held on Victory in Europe (VE) Day near Ciltvaria Street, named for the vessel.

May 9

2007—Sparks's Rodanthe Becomes Film

Filming began on Hatteras Island for the Warner Brothers movie *Nights in Rodanthe*, based on a 2002 Nicholas Sparks novel of the same name. The "cottage" Serendipity, oceanfront at Rodanthe's Mirlo Beach, played a prominent role in the film. During the movie shoot, locals had an opportunity to audition for bit parts and enjoyed bumping into various crew members and the movie's principal actors, Richard Gere and Diane Lane. After filming on Hatteras Island, the stars and crew headed to the Wilmington, North Carolina area for filming in that city and at Topsail Beach.

May 10

1962—New Bridge Provides Link from the West

The Lindsay C. Warren Bridge, the three-mile span over the Alligator River that connects mainland Dare with Tyrrell County, was dedicated. In his remarks at the ceremony, Warren, former congressman and past U.S. comptroller general for whom the bridge was named, pleaded for the removal of tolls in North Carolina and called out Governor Terry Sanford, who suggested tolls as a means of funding highway and bridge projects. The Lindsay C. Warren Bridge completed a direct motor route to and from Raleigh and points west without the need of a ferry ride. Following the speeches and a ribbon cutting, onlookers and dignitaries traveled west to Columbia for a parade and a barbecue.

May 11

1942—British Ship Torpedoed by U-558

The HMS *Bedfordshire*, a British trawler lent to the United States to aid in convoy duty and to help patrol local waters, was sent from its base at Morehead City, North Carolina, to investigate a possible U-boat prowling off Ocracoke Island. The following morning, the *U-558* sunk the *Bedfordshire*, taking with it the crew of thirty-four.

The burial of the crewmen from the HMS *Bedfordshire. Outer Banks History Center Collections, 1942.*

Four bodies from the ship later washed ashore on Ocracoke Island and were buried in the Williams family cemetery. After petitioning by island residents, the Williamses sold the plot to the State of North Carolina, which then leased the land to the British War Graves Commission, ensuring the seamen would eternally rest in British soil.

May 12

1972—Governor's Golf Tourney Gets Going

Practice rounds and the narrowing of the field were held for the second-annual North Carolina Governor's Invitational Golf Tournament, held that year in Kitty Hawk. The tournament, sponsored by the Outer Banks Chamber of Commerce, was a perfect opportunity to showcase Kitty Hawk's new Duck Woods and Sea Scape golf courses. While the event was chiefly for amateurs, a handful of professional golfers participated as guests of Governor Bob Scott, honorary chairperson. The Piedmont Crescent Country Club in Burlington, North Carolina, of which Governor Scott was a member, had ample representation with at least nine members participating in the tournament.

May 13

1941—Fruit and Vegetables Litter Beach

An estimated three to five hundred unmarked cases of fruit and vegetables washed up along a thirty-mile stretch of beach. Coastguardsmen and residents collected 230 cases of oranges, lemons, carrots, potatoes and onions in a fifteen-mile stretch between Caffey's Inlet and Kitty Hawk. The provenance of the cargo was unknown, and although no shipwrecks or maritime mishaps had been reported, Coast Guard crews searched the area by boat and air. It was estimated that the cargo had been in the water for two days. The citrus fruit was salvageable, but the vegetables were too waterlogged for consumption.

May 14

1954—Hondurans Rescued Near Chicamacomico

On its voyage from Philadelphia to Havana, Cuba, the Honduran freighter *Omar Babun* hit foul weather off the North Carolina coast. The ship was loaded with heavy machinery to build cement and steel works. Captain José Villa ran the *Omar Babun* aground north of Rodanthe after the cargo broke loose and threatened to sink the vessel. Thirteen men were rescued from the ill-fated ship by use of a breeches buoy, one of the last rescues of that kind on the North Carolina coast. The ship remained grounded at Rodanthe and for a time was an attraction for sightseers and photographers. It was later floated and towed to Norfolk.

May 15

1936—Spiral-Striped Beacon Replaced by Steel Tower

The Cape Hatteras Lighthouse shone a final time and began a fifteen-year operational hiatus. Although erosion near the base of the tower, which dates to 1870, was slowed by the installation of interlocking steel sheeting, serious narrowing of the beach caused the U.S. Lighthouse Service to abandon its use. Lighthouse commissioner Harold King admitted, "The lighthouse service has a great sentimental attachment for this old tower." Cape Hatteras was then marked by a flashing light on a tower made of steel. Known as the skeleton tower, the new structure cost $38,000 and was equipped with a bull's-eye-type lens visible between eighteen and twenty miles out to sea.

May 16

1949—First Flight Witness Takes First Airplane Ride

Colington Island fishing guide Johnny Moore, the last living witness to the Wright brothers' first flight in 1903, took his first airplane ride. After a morning of bass fishing, Moore accepted a ride with one of his clients, Syd Trott of Staunton, Virginia. On their brief flight, the pair soared over Colington Island, where Moore was able to get a bird's-eye view of the creeks and ponds where he guided his fishing parties. They also flew over the Wright Brothers Memorial. Trott's airplane took off from the new airstrip at the Carolinian Hotel in Nags Head.

May 17

1947—Special Press Group Meets at Hatteras

The Honorary Tar Heels were enjoying a meeting at Joe Massoletti's Fishing Lodge on Hatteras Island for one of their good-humored, convivial get-togethers. The group, which met regularly in the late 1940s and 1950s, was a collection of out-of-state travel and sportswriters and photographers who were brought to North Carolina and shown the finest in Tar Heel hospitality. Bill Sharpe of the North Carolina State Advertising and Publicity Bureau was chiefly responsible for extending invitations to the organization's affairs. When the gatherings grew in popularity they were later headquartered at the Carolinian Hotel in Nags Head. The spring 1947 meeting included fishing trips, photo opportunities and a visit from North Carolina governor R. Gregg Cherry. With all the activities planned, writers could return to their home newspapers or national magazines and write of the virtues of the Carolina Outer Banks.

May 18

1894—President Catches Bluefish

President Grover Cleveland, during a twelve-day hunting and fishing excursion, came ashore at the Cape Hatteras Lighthouse to have lunch. Cleveland was accompanied by Secretary of State Walter Q. Gresham and Secretary of the Treasury John G. Carlisle. Following their meal, the group took in a little surf fishing and caught nine bluefish and three red drum. While on their sojourn, the hunting party also did some shooting at Bodie Island. The men were traveling aboard the lighthouse tender *Violet* with Captain Robley Evans, an official with the U.S. Lighthouse Service. Robley was also known as "Fighting Bob" Evans for his exemplary and courageous service in the U.S. Navy.

May 19

1995—Backups at Wright Bridge to Become Thing of the Past

A second span of the Wright Memorial Bridge that connects mainland Currituck with the Outer Banks at Kitty Hawk opened to traffic, allowing twice as many cars to travel over Currituck Sound at the same time. The new westbound bridge measured twelve feet wider and four feet higher than its eastbound counterpart, which was built in the 1960s and replaced the original wooden span. It was hoped that the additional bridge would help to ease summertime traffic, which averaged twenty-four thousand cars per day and could top fifty thousand vehicles on a weekend turnover day when vacationers were beginning and ending their weeklong stays.

May 20

1896—Lifesavers Assist in Bringing Neighbor Home

The crew of the Gull Shoal Life-Saving Station on Hatteras Island responded to a signal from a schooner offshore three miles away from the station. When surfmen pulled alongside the vessel, they learned from the captain of the ship that a member of his crew was ill. The sick man was from Hatteras and wanted to be put ashore and return to his home. The surfmen landed the ill islander, along with his personal effects, and some men accompanied him southward toward his home on their evening beach patrol.

May 21

1932—Boater Bests Bear

While en route to pick up a fishing party in Manteo, I.M. Gallop of Harbinger encountered a black bear swimming in the Albemarle Sound about two and a half miles south of the Wright Memorial Bridge. The bear, most likely fatigued from his swim, attempted to climb aboard Gallop's boat. The enterprising Curritucker defended his vessel by delivering blows to the bear with the boat's tiller. After a final fatal strike, the bear expired and was then taken to Manteo, where it was determined to weigh four hundred pounds.

May 22

1939—Work on Area's First Seaside Pier Underway

Construction began on Jennette's Ocean Pier, the first fishing pier on the Outer Banks. The venture was financed by Elizabeth City's Warren H. Jennette Sr. and his brothers. The new attraction was conveniently located near Whalebone Junction and across the street from Sambo Tillett's restaurant. The land on which the pier was anchored had been a Works Progress Administration transient camp, and some of Camp Weaver's buildings were renovated to serve as overnight accommodations for fishermen. The pier opened in time for the summer season, and over time it grew in popularity. Over the years, the pier suffered damage from storms and even errant shipwrecks. Hurricane Isabel in 2003 dealt the historic structure its final blow, but a new concrete "green" pier was built in its place. It was dedicated in May 2011, with North Carolina governor Beverly Perdue and members of the Jennette family present.

May 23

2013—Pea Island Lifesaver Honored

A graveside Memorial Day ceremony was held at Corinth Baptist Church in Jarvisburg, Currituck County, North Carolina, to honor Benjamin Bowser, lifesaver of the Pea Island Life-Saving Station. Five flags were raised at the cemetery and flew for five days in honor of Bowser, who served at the famous all-black station from 1884 to 1900. He participated in the October 1896 rescue of the passengers and crew of the ship *E.S. Newman*, for which he was posthumously awarded the Gold Lifesaving Medal. Bowser, a native of Currituck County, followed Richard Etheridge as keeper of the Pea Island Station, serving in that capacity until his death.

May 24

1987—Reggae Fest Brings Arrests

The first and last Outer Banks Reggae Splash took place in Nags Head at the Outer Banks Coliseum, a former roller rink on the sound side near Milepost 16. The event was well attended, not only by music lovers, but also by law enforcement. Thirty-nine arrests were made during the event for underage drinking, possession of marijuana and psilocybin mushrooms and carrying a concealed weapon. Dr. Sarah Forbes, owner of the Outer Banks Coliseum, interrupted the show and called off the event a half hour before the scheduled end time due to "too much drinking" and "pot smoking and trouble in the parking lot."

May 25

2013—Tyrrell County Band Films Video

Jonny Waters and Company, a talented eclectic band from North Carolina's Inner Banks, was filmed for a country music video to accompany its popular single "Flip Flop Cowboy." The video shoot took place at several Nags Head locations, including the waterfront at Basnight's Lone Cedar, the pirate ship bar at Pamlico Jack's, aboard the charter boat *Strike 'Em* at Oregon Inlet Fishing Center and a "beach party" scene filmed next to the Outer Banks Fishing Pier, where local fans and supporters of the band with beach chairs, fishing rods and surfboards participated as extras.

Jonny Waters and Company films a segment for the "Flip Flop Cowboy" video. *Photo by and courtesy Michelle Warren, 2013.*

May 26

1932—Orville Wright Returns to Kitty Hawk

After attending the seventh-annual conference of the Aircraft Engineering Research Division of the National Advisory Committee for Aeronautics at Langley Field on the Tidewater Virginia peninsula, Orville Wright stopped by the Lighthouse Depot at Coinjock to visit William Tate. Wright was accompanied by Mr. Reid of the Langley Laboratories and requested that Tate join them on a trip to Kitty Hawk. Captain Tate served as the Wrights' host in their early trips to the area. During his brief visit to the Outer Banks, the aviation pioneer viewed the progress on the construction of the Wright Memorial, recollected various landmarks and relayed incidents that took place during the prelude to the first flight. Captain Kindervater, in charge of the Wright Memorial project, served what was described as a "splendid luncheon." Many old-timers who remembered the Wrights were visited, and Orville expressed gratitude for the courtesies extended to him.

May 27

1891—Ship's Master Expresses Gratitude in Letter

Hugh Beveridge wrote a letter of gratitude on this day on behalf of his daughters and the officers and crew of the bark *Vibilia* of Yarmouth, Nova Scotia. In the letter, Beveridge thanked keeper J.T. Wescott and the crew of the Poyner's Hill Life-Saving Station after they rescued Beveridge and his family off the stranded ship two days earlier. Wescott and crew rendered assistance to the stranded ship under "trying circumstances." In his letter, Beveridge also thanked Mr. T.J. Poyner of Popular Branch on the Currituck mainland for the hospitality provided during the stay at his home.

May 28

1993—America's Lighthouse Open for Climbing

With the help of a crew of volunteer tour guides, the Cape Hatteras Lighthouse opened to visitors following a nine-year, $1 million renovation. Officials closed the interior of the 1870 structure in 1984 due to deterioration of the beacon's iron steps. The outside balcony was put off limits in 1976 because of cracks in the ironwork. An estimated two thousand visitors a day were expected to tour the sentinel during the summer. Seventy-five people were permitted to climb the lighthouse at one time and were allowed to proceed at their own pace.

May 29

1986—Nonagenarian Crustacean Travels in Style

After spending two years at the Marine Resources Center (now known as the North Carolina Aquarium on Roanoke Island), ninety-three-year-old crustacean Harold the Lobster was transported to his new home at the soon-to-open Virginia Marine Science Museum in Virginia Beach. Seventeen-pound Harold, which was caught off Virginia in 1984, was flown from Manteo to Norfolk International Airport and arrived at the museum in a Rolls-Royce. He had been wrapped in wet towels and placed in a cooler laden with ice packs. Outside the brand-new facility, a banner reading, "Welcome Home Harold" greeted the celebrity lobster.

May 30

1952—Aviation Pioneer Remembered at Airport

A memorial service was held and a marker unveiled at the Manteo Airport honoring aviation pioneer Dave Driskill. A National Park Service pilot in the 1930s, Driskill transported supplies for the Civilian Conservation Corps and Works Progress Administration sand fixation project along the Outer Banks, flying from a Spartan airstrip at Skyco on Roanoke Island. He later flew tours for the Roanoke Island Flying Service. Many influential local citizens spoke at the service about Driskill's contributions to aviation on the Outer Banks. Driskill died in 1949, when the controls of the Kellet XR-10 helicopter he was flying failed.

May 31

1953—Stranded on Hatteras, Travelers Sleep in Cars

Several vacationers and day-trippers to Hatteras Island over the Memorial Day weekend were left on the south side of Oregon Inlet when the final ferry departed for the evening, and they were unable to reach the northern beaches. Seventeen or so cars did not make it onto the last run of the day, and their occupants were forced to spend the night in their vehicles. The unfortunate incident drew attention to the ever-growing problem of bottlenecks at coastal ferry points. Officials urged that additional routes be added at Oregon Inlet.

June 1

1972—Library Supporter Steps Down

Manteo native and grande dame Rennie G. Williamson stepped down from the Dare County Library Board, on which she had served for thirty-five years. Williamson supported the library since the institution's early days, when just thirty volumes made up its holdings. In addition to her library service, the talented and refined Williamson had a long list of contributions to the community, including chairing the Ladies' Serving Committee at the twenty-fifth anniversary of the Wright brothers' first flight, aiding in the planning of the Dare County Homecoming in 1926 and serving as organist and choir director at Mount Olivet Methodist Church for thirty years.

June 2

1953—Living Memorial to English Colonists Begun

A project of the North Carolina Garden Club got underway as construction began on Elizabethan Gardens. Local garden clubs throughout the state were able to promote Elizabethan Gardens, and it was frequently a discussion topic at club meetings. Several pieces of classical statuary valued at $100,000 were donated by Jock Whitney, sportsman, financier and philanthropist. The statuary pieces, which included a birdbath, fountain and sundial, were distributed about the gardens and acted as focal pieces throughout the site. The Elizabethan Gardens was the brainchild of garden women Inglis Fletcher, author of historical fiction, and Mrs. Charles A. Cannon, wife of the textile magnate.

June 3

1991—Youngster Flies Cross-Country, Lands Near Wright Memorial

Seven-year-old Daniel Shanklin, aided by a booster seat and blocks attached to the flight pedals, landed a plane at the Kill Devil Hills airstrip after an eight-day air journey from San Diego to the Outer Banks. The young aviator was greeted by three hundred second graders from Kitty Hawk and Manteo elementary schools. The students waved signs welcoming the young pilot to the birthplace of aviation. Shanklin was believed to be the first seven-year-old to fly coast to coast. Although there were no problems with his flight, Shanklin was not happy with his touchdown. "That was the worst landing I've ever had, and I wanted it to be the best," he was reported as saying.

June 4

1960—Incomparable Writer and Lover of Hatteras Rests at Sea

Author and newspaperman Ben Dixon MacNeill's ashes were scattered over Diamond Shoals per his request. Manteo's Quentin Bell and Bill Henderson were accompanied by reporter Russell Reynolds when the final rites were performed at sea. MacNeill, a popular North Carolina journalist, arrived on the Outer Banks in 1937 and worked as a publicist for *The Lost Colony* during its early years. His love of his adopted home, coupled with his writing style, landed many of MacNeill's stories touting the Outer Banks in newspapers across the state. He spent his retirement years writing from a small cottage at Buxton, in view of the Cape Hatteras Lighthouse. His books *Sand Roots* and *The Hatterasman* were published by John F. Blair.

June 5

1964—Lone Star and Tar Heel Governors Fish Marlin Tourney

Texas governor John Connally and North Carolina governor Terry Sanford at the International Marlin Tournament. *Aycock Brown Collection, Outer Banks History Center, 1964.*

After two days of fishing offshore, Texas governor John Connally and North Carolina governor Terry Sanford failed to catch a billfish in the Fifth Annual International Blue Marlin Tournament sponsored by the Hatteras Marlin Club in Hatteras Village. The pair of chief executives landed four dolphin on their first day of fishing, and the second day, Connally caught three ten-pound albacore. It was the Texas governor's first experience seeking blue marlin. New Jersey angler Joseph W. Janssen took top tournament honors after catching two marlin on the final day of the contest. Both of Janssen's catches were released.

June 6

1983—Bypass Becomes Croatan Highway

Heather Tolson, a sixth grader at Kitty Hawk Elementary School, was notified she was the winner of the "Name the U.S. 158 Bypass" contest that was sponsored by the beach-side towns through which the thoroughfare runs. Students from grades six through twelve were urged to pick a name reflecting the maritime, environmental or historical significance of the area. Tolson's winning entry, Croatan Highway, was chosen from a pool of more than two hundred suggestions. The second-place entry was submitted by a schoolmate of Tolson. Seventh grader Chris Picard suggested the name of Joebell Drive after the reddish-orange, daisy-like flower that grew in abundance in the area's sandy soil.

June 7

1975—Dare Tradition Initiated

Billed as a prelude to America's bicentennial, a two-day event took place in downtown Manteo. Dare Days featured music by the Flatlands Family Band and dancing by the Green Grass Cloggers, a concert by the Tactical Air Command Concert Band, a showing of the 1921 *Lost Colony* silent film at the Pioneer Theater, a fish fry, life-saving demonstrations, an art show, mobile history exhibits, a puppet show and a working model of a moonshine still that attracted the attention of many in the crowd. A highlight of the first day was the children's parade in which local youngsters dressed as patriotic figures of history. Although now only a one-day affair, Dare Day continues to be a late spring tradition held the first Saturday in June.

June 8

2006—Actress Redgrave Portrays
Queen Elizabeth in Lost Colony

British star of the stage, screen and television Lynn Redgrave completed a sixth and final performance in Paul Green's *The Lost Colony*, playing the role of Queen Elizabeth I. Redgrave ushered in the sixty-ninth production season to enthusiastic crowds. Jane McCullough, director of America's longest-running outdoor drama that season, knew Redgrave from school and helped to bring the actress to Roanoke Island for a string of performances at Waterside Theater. Strangely, while the story of *The Lost Colony*, based on the first English colonists in America, was very well known on Roanoke Island, Redgrave had never learned that lesson in history. She was also unfamiliar with the play.

June 9

1959—Charter Fisherman Lands Swordfish

Daniel Hickey of Philadelphia, fishing on Captain Harry Baum's *Jo Boy* thirty miles off Nags Head, became the first person to land a broadbill, also known as a swordfish, while fishing off the Outer Banks. The fish weighed eighty-nine pounds and measured eighty-eight inches long with a thirty-two-inch sword. Area promoters were quick to point out that four species of billfish (blue and white marlin, sailfish and broadbill) had now been caught in area waters. While uncommon, at least two swordfish were caught on charter boats fishing out of the Oregon Inlet Fishing Center in the summer of 2012.

June 10

1953—Celebrated Poet Frost Visits Outer Banks

Pulitzer Prize–winning poet Robert Frost visited Fort Raleigh during a trip to Roanoke Island. Adjacent to his name in the guest book, he wrote several lines from his poem "The Gift Outright." The seventy-nine-year-old writer swung by Dare County after receiving an honorary doctor of letters degree from the University of North Carolina at Chapel Hill. While on the Outer Banks, Frost was the guest of Southern Shores' Huntington Cairns. It was the poet's second visit to the area; he first came as a teenager in the 1890s. Before his death in 1963, Frost would publish a poem entitled "Kitty Hawk."

June 11

1962—Garden State Angler Gets World-Record Marlin Off Hatteras

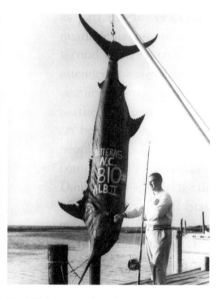

Gary Stukes poses beside his world-record blue marlin. *Aycock Brown Collection, Outer Banks History Center, 1962.*

Gary Stukes of Montclair, New Jersey, landed an 810-pound blue marlin off Hatteras while fishing aboard the *Albatross II* with Captain Bill Foster and his nephew Ernie Foster. The fourteen-foot marlin was a new world record. This fish tale has two ironic twists. Stukes was fishing with a seasoned angler, a Mr. Sloat, who had his heart set on catching a world-record marlin but had given Stukes a turn in the fighting chair. Stukes's catch was made days before forty anglers from the United States, Panama, South Africa and Venezuela converged on Hatteras Island for the International Blue Marlin Tournament.

June 12

1979—French Explorer Studies USS Monitor *Site*

Sixteen miles off Cape Hatteras, undersea explorer Jacques Cousteau was aboard his 140-foot ship *Calypso*, equipped with $1 million in specialized technical equipment to investigate and film the sunken ironclad USS *Monitor.* The expedition hoped to collect between three and five minutes of footage for a documentary about notable shipwrecks, but conditions this day were less than ideal. A recent storm had churned up the sea and impaired underwater visibility. The venture marked the first time that the Cousteau Society was required to complete an application before embarking on a research trip. The special paperwork was required by the *Monitor* Technical Review Committee.

June 13

1998—Female Rower's Atlantic Crossing Delayed

Tori Murden prepares to take off on a transatlantic rowboat journey near Oregon Inlet.
Photo courtesy Tori Murden McClure, 1998.

Tori Murden, who was scheduled to depart on a transatlantic solo voyage in a thirty-two-foot rowboat, was delayed for a day because of a glitch in her vessel's water purification system. The thirty-five-year-old rower from Louisville, Kentucky, started her journey from the Oregon Inlet Coast Guard Station with hopes of finishing in Brest, France, but experienced high seas after eighty-five days out and abandoned her boat. Although thwarted on her attempt to cross the sea on this voyage, the adventurer became the first woman to make the Atlantic crossing in a rowboat the following year when she rowed her boat, *American Pearl*, westward from the Canary Islands to Guadeloupe. She wrote a book about her adventures, *A Pearl in the Storm: How I Found My Heart in the Middle of the Ocean.*

June 14

1961—Resort Town Incorporates for Second Time

In the North Carolina General Assembly, Chapter 808, House Bill 913, *An Act to Incorporate the Town of Nags Head in Dare County* was read for the third time and ratified. In addition to defining the boundaries of the town, the act appointed Lionel Edwards, Tom McKimmey, Julian Oneto, James Scarborough and Carlton Gilliam to serve as the governing board of the town until voters could elect a mayor and four commissioners. This was the second time that the seaside resort incorporated. Nags Head incorporated in the 1920s, but the charter lapsed due to inactivity. In 2011, the town celebrated the fiftieth anniversary of its second incorporation with a carnival, T-shirts, a keepsake cookbook and a gala at the recently opened Jennette's Pier.

June 15

2008—Air Quality Poor as Fire Continues on Mainland

Residents of and visitors to eastern North Carolina were urged to reduce normal time outdoors and stay indoors if possible to avoid smoke from a massive wildfire at the Pocosin Lakes National Wildlife Refuge in Beaufort and Washington Counties. Warnings covered a widespread area that included Kill Devil Hills, Manteo, Nags Head, Elizabeth City, Edenton, Plymouth and Washington. Stagnant conditions caused extremely reduced visibility and exacerbated the poor air quality. The fire, started by a lightning strike two weeks earlier, had burned approximately forty thousand acres in an area sixty square miles. Over five hundred firefighters were working to contain the blaze.

June 16

1969—Nags Head Officials Tired of Hot Air

At the regular meeting of the Nags Head Board of Commissioners, the heat and humidity of the season took a toll on town board members. During the meeting, they voted to approve a bid from Fearings, Inc., of Manteo to purchase an air conditioner for Nags Head Town Hall. Fearing's bid was $248 for the twelve-thousand-BTU unit. Mayor Clarence Brickle, whose face was described as "filmed in sweat," spoke in favor of the need for the air conditioner. The four commissioners were of like minds with the mayor and approved the expenditure.

June 17

1999—America's Lighthouse Starts Journey

The Cape Hatteras Lighthouse during its move away from the sea. *Photo by Mike Booher, Outer Banks History Center, 1999.*

The black-and-white-spiral-striped Cape Hatteras Lighthouse, which had been precariously lifted onto hydraulic jacks and placed onto a transport system, began its 2,900-foot move to the southwest to save it from the encroaching Atlantic Ocean. At 3:05 p.m., International Chimney Corporation, aided by Expert House Movers and other contractors, first moved the tallest lighthouse in America five inches in a test run and then moved the beacon an additional ten feet. The entire journey would take twenty-three days to complete. It was estimated that thousands of people from across the country visited Buxton to watch the historic event, much to the pleasure of local merchants.

June 18

1979—Oil Fouls Beaches, Worries Business Owners

Nags Head beaches between Jennette's Pier and Jockey's Ridge were closed after balls of oil washed up from Cape Hatteras to Duck. The U.S. Coast Guard closed stretches of the beach in order to clean up oily sand quickly and without interference from beachgoers. It was thought that the oil originated from a passing ship when it cleaned its tanks. The globs of oil were reported to range in size from a black-eyed pea to a fifty-cent piece. As vacationers cancelled reservations, hotel and restaurant workers and business owners who catered to visitors were concerned about the oil's effect on the upcoming Fourth of July holiday.

June 19

1943—East Lake Youths Honored on Radio Program

Seven young men from the community of East Lake on the Dare County mainland were honored on the radio program *Youth On Parade*, broadcast on the Columbia Broadcast Network and aired on several North Carolina affiliates. The boys, members of the 4-H Club, were recognized for their swift and valiant actions two months earlier, when they discovered a fire burning near their school. After obtaining permission from their teacher, the boys went to report the fire to the warden at the fire tower, who was atop the lookout working for the Aircraft Warning Service, unable to leave his station. He instructed the boys to get the firefighting equipment, telling the oldest to drive his car to retrieve it. The boys fought the fire for two hours and then worked on putting out hot spots until the blaze was completely under control. The young men were sixth, seventh and eighth grade students at East Lake School.

June 20

1991—Monitor *Damaged When Fishing Boat Drops Anchor*

Divers from the National Oceanic and Atmospheric Administration inspected the sunken remains of the USS *Monitor* after a private fishing boat anchored within the one-mile restricted area of the Monitor National Marine Sanctuary. Evidence showed that the anchor had scraped marine life off a portion of the ship, exposing the ironclad's metal to salt water, and that the *Monitor*'s skeg and propeller shaft had been moved. The famous ironclad ship that dueled with the *Merrimac* at Hampton Roads sank off Cape Hatteras in 1862. It was declared a National Marine Sanctuary in 1975.

June 21

1903—Off-Season Crew Rescues Men from Stranded Schooner

The four-masted schooner *Lucy H. Russell*, sailing from Boston to Brunswick, Georgia, grounded near shore a half mile south of the Gull Shoal Life-Saving Station. The station keeper discovered the vessel at about 4:30 a.m. Although the predawn wreck occurred during the off season, when the stations were not manned, a temporary crew was assembled and made several trips aboard the *Lucy H. Russell*. The lifesavers brought the *Russell*'s crew of nine to the station, where they were provided for over a number of days. The ship went to pieces in the surf, and the wreck was stripped and sold at auction on July 13. Paperwork filed with the station keeper listed miscalculation as the cause of the stranding.

June 22

1933—Manteo and Murphy Connected by Paved Road

A long-awaited goal of North Carolinians was realized when the final paved stretch of asphalt road connecting the county seats of the Tar Heel State was completed. The final fourteen-mile portion of the highway ran through Currituck County from Grandy to Point Harbor. A formal dedication and opening took place on July 1, when E.B. Jeffress, chairman of the State Highway Commission, cut the ribbon. A motorcade then traveled to the end of the road at Old Fort Raleigh on Roanoke Island. Currituck's Chester Morris acted as master of ceremonies and introduced VIPs in attendance. State representative R. Bruce Etheridge introduced the main speaker, Charles L. Johnson, a representative of Governor Ehringhaus.

June 23

1937—Rare Flamingo Sighting at Refuge

Samuel A. Walker, manager of the Pea Island Wildlife Refuge on Hatteras Island, reported seeing two flamingos on the federal preserve. It was the first reported sighting of the tall pink wading bird on the refuge, but other flamingo sightings were reported in 1964, 1969, 1972 and during the winter of 1978–79. Flamingoes have also been spotted on the Outer Banks in Buxton in 1951 and at Ocracoke Inlet in 1978.

June 24

1992—Sorry Charley! Huge Tuna Ends Up in Dump

Armed federal fisheries agents confiscated a thousand-pound blue fin tuna worth $40,000 from an area fish house. Local fishermen were livid when they learned that the fish ended up in the Dare County landfill. The fishermen were also not happy about the bureaucratic regulations that threatened their ability to make a living. The fish in question was caught in an area that was closed to landings. The normal protocol for fish caught under alleged violations was to sell them and hold the money in escrow until settlement, but the tuna had been unrefrigerated for too long.

June 25

1998—Stinky Boat Gets Unstuck

A 165-foot menhaden trawler, the *Shear Water* out of Reedville, Virginia, floated off a sandbar one hundred feet from shore, five miles north of Rodanthe, where it had been stuck for a week. The trawler, owned by Houston-based Omega Products, floated off the bar at high tide. It was loaded with six hundred tons of menhaden, known colloquially as fatback, bunker or pogie. Because the crew shut down the vessel's refrigeration system before abandoning the ship, the *Shear Water* was ripe with the odor of rotting, oily fish. Officials worried that the decomposing fish could trigger health concerns. The stranded trawler became a sight to see for visitors to the Pea Island National Wildlife Refuge.

June 26

1966—Search Teams Scour Beach for Airplane

After a private plane carrying two people from New Bern, North Carolina, to Manteo was reported missing, search parties hunted for any sign of the missing aircraft or its pilot and passenger. Leroy French was flying with passenger Linda Jane McGroaty when he radioed pilot Rudy DeRosa to report that weather was so bad he was going to attempt to land on the beach. DeRosa was flying nearby and reported the incident to authorities. Because of the poor weather, the Coast Guard was unable to search by air until the following morning. After days of air and land searches with no signs of the missing plane, French and McGroaty were feared dead.

June 27

1959—"Dare County Day" Marks Lost Colony Opening with Fanfare

A plethora of events were held in conjunction with opening night of *The Lost Colony*, which was celebrating its nineteenth season. The pre-performance activities were billed under the celebratory banner of Dare County Day and included a boat parade in the sound; a water ski show; authentic Indian dances performed by a Portsmouth, Virginia Boy Scout troop (which won a national award for its dancing prowess); a free picnic for out-of-town guests; and pre-performance fireworks. Locals were encouraged to pack picnic suppers and take in the events at Waterside Theater. An important history lesson was told, too, when members of the cast of the 1921 silent movie about the colonists shared their remembrances of the event. Among those movie cast members in attendance were R. Bruce Etheridge, Alpheus W. Drinkwater, Mabel Evans Jones and D. Victor Meekins.

June 28

1985—License Plate Swiper Duped by Local Law Enforcement

A Kill Devil Hills man pleaded guilty to forty-eight counts of misdemeanor theft, and a cohort pleaded guilty to being an accomplice. The twenty-year-old was on a quest to collect license plates from all fifty states. His task was aided by the influx of vacationers on the Outer Banks each week. After receiving numerous reports from vacationers about out-of-town plates being stolen, the police baited the thief with a Hawaii license plate placed on an unmarked car. The wrongdoer was arrested just two plates short of his goal.

June 29

1585—Flagship of Roanoke Voyage Grounds at Inlet

One of the first known shipwrecks on the North Carolina coast occurred when the *Tiger*, flagship of the first of Sir Walter Raleigh's Roanoke Voyages, attempted to sail through Ocracoke Inlet and struck a shoal. Although the vessel was saved from breaking up, it was beached, and a large number of much-needed provisions—corn, salt, meal and other goods—were damaged by salt water, rendering them unusable. This left the colonists with supplies to last them just twenty days and forced them to negotiate with the natives. The next month, the *Tiger* was repaired, refloated and sailed on to meet the other ships of the expedition.

June 30

1990—Walkers Inaugurate New Baum Bridge

Weeks prior to opening to traffic, the new Washington Baum high-rise bridge connecting Nags Head and Roanoke Island was opened to pedestrian traffic for an afternoon bridge hike. The new $15.8 million span, built by the Holloway Construction Company, replaced a two-lane swing-span bridge built in the 1950s. Nags Head mayor Don Bryan and Manteo mayor Luther Daniels joined in the celebration and led the procession across the new structure. Participants in the bridge walk donated $1 to benefit the Outer Banks American Youth Hostels Club. A total of $816 was collected.

July 1

1957—Electric Company Switches Power

Virginia Electric and Power Company (VEPCO) purchased Roanoke Utilities, Inc., the company that provided electricity to Manteo and Roanoke Island. As part of the transition, VEPCO installed modern streetlights, which debuted at 8:00 p.m. A public celebration took place in front of the Dare County Courthouse, where Mayor Martin Kellogg had the honor of switching on the new, up-to-date lights. The new and improved streetlights were just the first step in a major overhauling of Roanoke Island's electric infrastructure. A temporary VEPCO office was set up downtown until a larger, more permanent one could be built.

July 2

1978—Ocracoke Haven for Beachgoers in the Buff

An article published in Norfolk's *Virginian Pilot* newspaper drew attention to the out-of-the-way and secluded beaches on Ocracoke Island as places where people were able to sunbathe au natural. Most of the nakedness took place on the stretches of undeveloped beach north of the National Park Service campground. The article tipped off local law enforcement about the swimsuit-optional practice, and the Hyde County sheriff instructed his deputies to begin issuing citations to those who sunned sans suits. While there were no rules about nude sunbathing on Park Service property, nude beachgoing was forbidden by North Carolina law, and National Park Service policy was to "conform to local traditions."

July 3

1935—Bridges Become Toll-Free

After a meeting of the North Carolina State Highway and Public Works Commission and the Dare County Board of Commissioners, the state took over possession of both the Wright Memorial Bridge and the Roanoke Sound Bridge. At midnight, the tolls on both bridges were abolished. It was predicted that with the tolls removed, property values on the Dare Beaches would soar, and the future of real estate transfers looked bright. It was also reported that there was much activity on the Outer Banks on the Fourth of July because of the removal of the bridge tolls. Although Dare officials were not happy with the price received for the bridge, there was much positive public sentiment toward abolishing the fee to cross it.

July 4

1937—The Lost Colony *Debuts*

Paul Green's *The Lost Colony* premiered at Waterside Theater on Roanoke Island, with many roles played by island natives and longtime summer people from Nags Head. The production entertained the audience, telling the story of Sir Walter Raleigh's ill-fated colonists of 1587 through drama, music, pantomime and dance. The crowd on opening night was estimated at 2,500 people. The play continued each summer, until the stage lights dimmed during the war years. The drama/pageant resumed in 1946 and continued each summer. In its early years, *The Lost Colony* nurtured the growing tourist industry, bringing visitors to the Dare Beaches to see the pageant and perhaps stay overnight at a tourist home or seaside inn and dine in an area restaurant.

July 5

1935—An Institution Is Born

Dare County's first newspaper, the *Dare County Times*, published its first issue. Roanoke Island native D. Victor Meekins was editor of the new weekly. He learned the newspaper business in Elizabeth City, working for W.O. Saunders at the *Independent*. North Carolina governor J.C.B. Ehringhaus, Congressman Lindsey C. Warren, North Carolina Department of Conservation and Development director and Dare native R. Bruce Etheridge and Dare County Chamber of Commerce secretary and *Lost Colony* promoter D.B. Fearing had congratulatory messages printed on the front page. The newspaper is still published today as the *Coastland Times* by Meekins's kin.

July 6

1968—Vacationers Terrorized with Whip

A small group of Chesapeake, Virginia young men ranging in age from nineteen to twenty-two attacked and intimidated vacationers who were climbing the sand dune Jockey's Ridge in Nags Head. The ringleader assaulted dune climbers and hikers with a horsewhip, threatened others with a knife and made inappropriate gestures and used indecent language toward young women. The miscreants were apprehended in marshy terrain after a three-and-a-half-hour chase by a number of law enforcement officers from the Nags Head Police Department, Dare County Sherriff's Office and the North Carolina Highway Patrol.

July 7

1951—Photographer Shoots Barefoot Dancers for Parade Magazine

New York photographer Allan Gould, during a ten-day stay at Nags Head, snapped photos for three separate assignments and captured images of shoeless dancers at the Nags Head Beach Club. The photographs were used to illustrate an article in *Parade* magazine about the barefoot nightclub. While on the Outer Banks, Gould also played a bit part in *The Lost Colony* and photographed the play with a small camera mounted on a cane. Over at the Carolinian Hotel, Gould shot a color layout for *Redbook* magazine to accompany an article about the Oneto family, who helped manage the inn.

July 8

1938—First Blue Marlin Landed with Rod and Reel

New Jersey sportsman Hugo Rutherford, fishing aboard his boat *Mako*, landed the first blue marlin caught with a rod and reel off Cape Hatteras. The fish weighed in at 439 pounds and measured twelve feet from tip to tail, with a girth of fifty-eight inches. Its tail was forty-seven inches across. The fish was an ample match for Rutherford, who was purported to be a large man. Another marlin was taken not long after Rutherford's catch, but marlin fishing was slow to grow in popularity because of the specialized equipment needed to catch the big fish.

July 9

1949—Kay Kyser in Kill Devil Hills

Popular bandleader and Rocky Mount, North Carolina native Kay Kyser arrived with his wife, Georgia, for a stay in a Kill Devil Hills cottage. Kyser was known for his orchestra and musical act *Kollege of Musical Knowledge*, which was broadcast on the radio. Mrs. Kyser, professionally known as Georgia Carroll, was an entertainer as well. While vacationing, the Kysers dined at the Croatan Inn near their cottage. Kay Kyser would introduce Emma Neal Morrison to *The Lost Colony* while they were vacation neighbors in Kill Devil Hills. Morrison, of Washington, D.C., would become an avid supporter of the outdoor drama for fifty years.

July 10

1990—Biking Trio Ends Cross-Country Trip at Nags Head

Three former co-workers ended a month-long bicycle ride across the United States when they pedaled into Nags Head. During their trek, which started out in Spokane, Washington, they endured sore knees and worn behinds alleviated to some degree by lots of Advil. After arriving on the Outer Banks, they marked the end of their journey by wading in the Atlantic Ocean. The bikers rode over three thousand miles and averaged over one hundred miles per day, overcoming obstacles of excessive heat, traffic and physical pain.

July 11

1861—Union Gunboats Cause Confederate Stampede

Confederate troops, assisted by black laborers and slaves, were encamped near Oregon Inlet when three Union steamers appeared off shore. The Confederates opened fire, which was returned by the USS *Albatross*. Panic ensued. It was reported that officers conducted themselves in such a manner as to "completely demoralize their men." In a confusing mass exodus, soldiers were seen retreating by wading and swimming. Fearing for their lives, the 130 black workers rushed into the marshes to escape the shelling. Confederates believed that the Union vessels would land at New Inlet and feared enemy troops would take possession of a cache of muskets stored in the Bodie Island Lighthouse.

July 12

1813—Revenue Cutter Mercury *Escapes British at Ocracoke*

The U.S. revenue cutter *Mercury*, captained by David Wallace, gave British ships the slip when they appeared at Ocracoke Inlet. The Brits captured two American vessels, the *Atlas* and the *Anaconda*. Troops one thousand strong began an occupation of Portsmouth Island. Before heading inland to New Bern to share the news of the British invasion, important papers and documents from the U.S. Customhouse on Portsmouth were loaded onto the *Mercury*, where they were saved from the wanton destruction in the harbor town. In New Bern, citizens were able to take precautions and prepare for possible invasion.

July 13

1984—America Celebrates Four Hundred Years

Her Royal Highness Princess Anne visited Roanoke Island as part of America's 400th-anniversary celebration—the quadricentennial of the Roanoke Voyages. The princess, second child and sole daughter of Queen Elizabeth II, attended the dedication of the *Elizabeth II*, the sixteenth-century representative sailing ship now permanently berthed on Roanoke Island. The princess gave her regards on behalf of her mother, the queen, and all the British people. Other events of the day included the issuing of a commemorative stamp and the dedication of the Cora Mae Daniels Basnight Bridge that connected downtown Manteo with the Elizabeth II State Historic Site. North Carolina governor Jim Hunt gave Manteo mayor John F. Wilson IV accolades for his efforts to aid in the special celebration.

July 14

1962—State and Federal Officials Survey Seashore

North Carolina governor Terry Sanford and U.S. secretary of the interior Stewart L. Udall met on the Outer Banks with Park Service director Conrad Wirth and Congressman Herbert C. Bonner to discuss possible expansion of the Cape Hatteras National Seashore. Stabilization and preservation of the state's beaches in cooperation with the Park Service were at the top of Sanford's list. Udall believed the seashore expansion project would be a good one for the proposed Youth Conservation Corps. National seashore boundaries at that time ran from Whalebone Junction to Ocracoke Island, but the new proposal to expand the park eyed the beaches of Currituck Banks and Cape Lookout.

July 15

1999—The Today Show *Broadcasts Live from Nags Head*

Matt Lauer poses with the Outer Banks Chamber of Commerce's Angie Brady Daniels. The two appeared together on *The Today Show*. *Outer Banks Chamber of Commerce photo, 1999.*

The Outer Banks were abuzz when Matt Lauer and *The Today Show* broadcast live from the Village at Nags Head Beach Club in the seaside town of that name. An enthusiastic group of locals and vacationers were on hand, despite the drippy weather, to cheer, wave and display signs. Local NBC affiliates from Norfolk, Virginia, and Greenville, North Carolina, gave live updates, and local radio stations WNHW and WYND broadcast live from the scene. Lauer was joined by Angie Brady Daniels of the Outer Banks Chamber of Commerce. Daniels remembered, "Being a major network trying to out-scoop the competition, the story lines kept changing." During the show, a hang glider landed on the beach, and someone gave a fly-fishing demonstration. For the occasion, T-shirts were printed with "Outer Banks Welcomes the NBC *Today Show*" on the front and "Where's Katie?" on the reverse. Katie Couric, Lauer's *Today Show* co-host, was on the boardwalk in Atlantic City for the split broadcast.

July 16

1946—Dare County Eyes Surplus Infirmaries

Congressman Herbert C. Bonner announced that plans for Dare County's taking over two ten-bed infirmaries to use as local hospitals looked promising. A county delegation filed paperwork with the War Assets Administration with hopes that the buildings could be used to meet local healthcare needs. The infirmaries were surplused by the U.S. Coast Guard and valued at $30,000 each. They were constructed to house victims of merchant ships torpedoed by German submarines. One of the buildings was located in Buxton and the other in the Nags Head area. It was determined that the county could not afford to operate the infirmaries without state assistance.

July 17

1963—The Old Dominion and Old North State Take in Lost Colony

Virginia-Carolina Friendship Night took place at Waterside Theater on Roanoke Island, where North Carolina governor Terry Sanford welcomed Virginia governor Albertis Harrison Jr. for a viewing of Paul Green's *The Lost Colony*. Two nights later, Mrs. O. Max Gardner of Shelby, North Carolina, headed Former First Ladies' Night at Waterside Theater, where spouses of past North Carolina governors viewed the historical pageant with current first lady Margaret Rose Sanford. Other special nights during the season included welcoming members of Home Demonstration Clubs and Garden Clubs of North Carolina and hosting Conrad Wirth, the director of the National Park Service. Wirth gave a special presentation one evening about improvements to and expansion of the Fort Raleigh National Historic Site.

July 18

1989—Weather Cooperates with Griffith and Matlock *Crew*

Although rain was forecast, Andy Griffith and the crew of the television show *Matlock* had a perfect day for filming outdoors. The cast and crew were at work on the two-hour, $2.5 million season-opener filmed in part on Roanoke Island and at Coquina Beach. While in Dare County, the crew bunked at the Elizabethan Inn while the cast stayed at the Tranquil House Inn. It was the first time that the whole crew had been together for a shoot. During the filming, between July 17 and August 4, many locals had the opportunity to play bit parts in the episode entitled "The Hunting Party." Shoots were held at Queen Anne's Revenge and the Green Dolphin pub. The location director noted that things ran smoothly because of the cooperativeness of the locals.

July 19

1995—The Intimidator and Governor See Manteo

R.V. Owens delivers remarks at the dedication of the ferry *Thomas A. Baum*. North Carolina governor Jim Hunt (in dark jacket) and Dale Earnhardt (to Hunt's left) were on hand for the event. *Outer Banks History Center Collections, 1995.*

North Carolina governor Jim Hunt and NASCAR legend Dale Earnhardt were on the Manteo waterfront to attend the christening of the ferry *Thomas A. Baum*, a new 149-foot vessel in the North Carolina ferry fleet. Built by Steiner Shipyard in Bayou La Batre, Louisiana, the vessel was named for Thomas A. Baum, who operated a ferry between Point Harbor and Kitty Hawk and Point Harbor and Manteo. The day, although overcast, was as sultry as they come, hot with air so thick it took effort to breathe. Manteo town never looked better. The Cora Mae Daniels Basnight Bridge that connects downtown with Ice Plant Island was a-flutter with U.S. and North Carolina flags.

July 20

1933—Pressmen Meet in Dare

As part of the five-day annual meeting of the North Carolina Press Association that convened in Dare County, a banquet was held at the Kitty Hawk Beach Casino. Two hundred tickets were available to the dinner. Trout, julienned potatoes, sliced tomatoes and peas were served. W.O. Saunders, the keynote speaker, presented a speech, "Progress in the Carolina Coastland During the Past 30 Years." Dancing followed to the sounds of the Carolina Buccaneers. Other events included a fishing trip in Roanoke Sound, a demonstration of locally built speedboats and an opening night dance at the Nags Head Casino.

July 21

1954—Flying Grandmother Visits Outer Banks in Personal Plane

After attending *The Lost Colony* and spending the night in Dare County, sixty-six-year-old colorful Zaddie R. Bunker, a pilot and great-grandmother from Palm Springs, California, took off from the Manteo airport in her plane, which she dubbed "Zaddie's Rocking Chair." The aviatrix ended a coast-to-coast trip of short flights when she cruised over Kitty Hawk before landing on Roanoke Island. Her summer trip also included stops at the Powder Puff Derby in Knoxville, Tennessee, and in Asheville, North Carolina, for the Silver Anniversary Meeting of the international assembly of the Ninety-Nines, a women's flying organization.

The ebullient Zaddie Bunker poses for a photo at the Dare County Regional Airport. The sixty-six-year-old pilot flew over Kitty Hawk on her coast-to-coast air trip. *Aycock Brown Collection, Outer Banks History Center, 1954.*

July 22

1900—Lifesavers Respond in Off-Season

Although it was the inactive season for the U.S. Life-Saving Service along the Outer Banks, keepers and volunteers from the Cape Hatteras and Creeds Hill Stations responded to the stranded German steamer *St. George*, which had become stuck on the southwest point of Diamond Shoals nine miles southeast of the Cape Hatteras Station. The men from the crews boarded the vessel and extracted it from the sand. To complete their task, the ship was navigated around the shoals and steered on a safe course.

July 23

1965—Eight Killed When Trawler Catches Torpedo

While trolling for deep-sea scallops forty-five miles off Currituck Banks, the seventy-one-foot trawler *Snoopy*, fishing out of Portland, Maine, was destroyed after snagging a German torpedo in its fishing net. Eight of twelve crewmen were missing and presumed dead after the explosion, which left *Snoopy* in splinters. Coast Guard aircraft reported to the scene of the explosion, dropped flares and worked in their glow. Cutters from Norfolk and Ocracoke rushed to the scene. Four survivors were taken aboard the trawlers *Explorer* and *Prowler*, which were scalloping nearby. The fishermen, in critical condition, were later taken to Norfolk.

July 24

1947—Lost Colony *Theater Burns*

Waterside Theater, home of *The Lost Colony*, caught fire, and by the time the flames were out, the dressing rooms and two-thirds of the backstage area had been destroyed. Damage was estimated at between $50,000 and $75,000. The quick-thinking Irene Smart, company costumer, worked with the help of a few others to move hundreds of costumes out of harm's way. Although damage to the theater was great, Albert Q. "Skipper" Bell, the architect of the structure, said, "Give me some lumber and some men and I will rebuild the theater in four or five days." Members of the cast and company, along with islanders, worked in eight-hour shifts, and with their volunteer labor and donated material, the theater was rebuilt. The play resumed on July 30.

July 25

1974—Sand Dune Receives Landmark Status

Jockey's Ridge and the surrounding sand dunes system in Nags Head was declared a National Natural Landmark recognized for its special significance. The living dunes, or medanos, shift, grow and decline with seasonal winds. In addition to the dune environment, Jockey's Ridge was also recognized for its maritime forest and Roanoke Sound estuary habitats. While Jockey's Ridge was known for its natural beauty, it was—and remains—home to a variety of animal and plant species, including the threatened wooly beach heather. Through the efforts of citizen groups, the dune system was made a state park the following year. Today, Jockey's Ridge State Park is the most visited state park in North Carolina, with over one million visitors annually.

July 26

1974—Thousand-Pound Marlin Landed

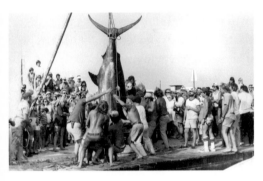

Mates work to unload a world-record blue marlin that weighed in at 1,142 pounds. *Aycock Brown Collection, Outer Banks History Center, 1974.*

While fishing with Captain Harry Baum on the *Jo Boy* out of Oregon Inlet, Jack Herrington of Allison Park, Pennsylvania, became the first person to land a marlin weighing over 1,000 pounds. After the fish was brought to the dock, where a large crowd had assembled to view the behemoth, it was precariously unloaded and taken to the Hatteras Marlin Club in the back of a pickup truck because there were not enough counterweights at the Oregon Inlet Fishing Center to weigh the trophy catch. The 1,142-pound blue marlin became a state and world record. While the world record was broken three years later, Herrington held the state record for over thirty years.

July 27

1976—Citizens Visit Raleigh to Draw Attention to Access Issues

Members of Currituck Outer Banks Residents for Action, or COBRA, traveled to the governor's office in Raleigh. On their agenda was the relaying of their plight of isolation due to U.S. Department of the Interior regulations that limited passage through the Back Bay National Wildlife Refuge to Virginia Beach. The only other option for residents of Corolla and Carova was to drive the hundred-mile route south and across the Wright Memorial Bridge. Original restrictions forbade travel between 9:00 p.m. and 6:00 a.m., but later the restrictions were increased to limit beach driving only between the hours of 6:00 and 9:00 a.m. and 5:00 and 8:00 p.m.

July 28

1587—Englishman Killed While Crabbing

George Howe, assistant to Governor John White on the Roanoke Voyage of 1587, was killed by unfriendly natives while he was crabbing alone on the west side of Roanoke Island. Howe, who was a mile or two away from the settlement, was wading in the shallow waters of the Croatan Sound and was unarmed other than a forked stick. He received multiple arrow wounds that were followed by blows to the head. The natives then retreated across the Croatan Sound to the mainland.

July 29

1979—Hot Crowd at Meeting on Beach Driving

The convention room at the Armada Hotel was filled with two hundred people for a three-hour hearing about driving on the beach within the limits of the town of Nags Head. More than thirty people, some representing organizations and others representing themselves, spoke at the hearing. At issue was a perceived threat to public safety and the environment versus traditional access to the town's beaches. A majority of speakers and those who had submitted written comments favored allowing driving during the off-season between mid-September and mid-May. Spectators and participants at the meeting endured less than ideal climate conditions because the hotel's air-conditioning system was on the fritz.

July 30

1990—Medical Waste Collected from Beach

U.S. Navy officials arrived in Dare County to inspect medical waste that washed ashore on Currituck and Dare County beaches while navy teams, assisted by volunteers, continued to search for debris from the North Carolina state line to Kill Devil Hills. Most of the waste—over seventy-five items—consisted of gauze, hypodermic needles and intravenous fluid bags, which were unused and presented no threat to public safety. One item was labeled as coming from the USS *Theodore Roosevelt* and other items from the USS *Gunston Hall*. Three years later, medical waste attributed to the *Gunston Hall* washed ashore near Cape Lookout, North Carolina.

July 31

1978—Waterspout Stuns Summer Vacationers

At the peak of vacation season, on an otherwise regular summer day, a large and powerful waterspout developed over the Atlantic Ocean and slowly ambled ashore in Kill Devil Hills, killing a woman and striking the unoccupied Wilbur Wright Hotel. The twister, which struck at 1:30 p.m., during the middle of the day when the beaches were full, frightened sunbathers and ocean-goers as it continued west, demolishing several cottages in its path. Three people were taken to the medical center in Nags Head and treated for minor injuries.

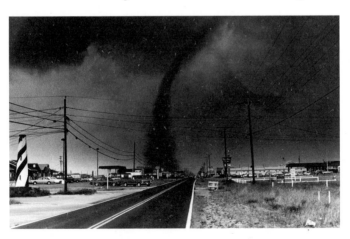

One person was killed when this waterspout came ashore at Kill Devil Hills. *Photo by Walter C. Gresham, gresham-photography.com, 1978.*

August 1

1998—Life Guards Spend a Busy Week and Then Some

A ten-day stretch of dangerous currents began along the Outer Banks. When it was over, 716 people were rescued from the treacherous Outer Banks surf. It started when winds whipped the ocean and waves weakened sandbars, creating hazardous rip currents. While only seven cases were confirmed as near drownings, the rough ocean kept first responders busy for over a week, even though the red flags were flying and the beaches were closed. Guards did all they could to keep vacationers out of the sea, but the red flags were often ignored. The odd pattern that created the tides was described as a "freak of nature."

AUGUST

August 2

2000—Dare's Runway Too Short for Commercial Service

The president and CEO of Midway Airlines visited the Dare County Regional Airport for a tour and inspection of the Roanoke Island facility, but plans for commercial air service between Manteo and Raleigh-Durham International Airport were put on hold because of the length of Dare's runway. Midway officials wanted to tap into the Outer Banks market area; however a 5,000-foot runway was needed for safety and profitability. The runway at the Dare County Regional Airport, at 4,200 feet, was 800 feet too short. Other airline companies were interested in serving the area but also expressed the need for a longer runway.

August 3

1960—Gulf Stream Dolphin Eats Bullet Casing

A group of offshore anglers received a surprise after a trip to the Gulf Stream on Captain Willie Etheridge's charter boat, *Chee-Chee*, out of Oregon Inlet Fishing Center. They reeled in a dolphin fish (mahi-mahi) and later discovered that the creature had a machine gun shell in its belly. The .20-millimeter casing was found when the dolphin was being cleaned. It was speculated that the casing fell from a military aircraft working on target practice maneuvers and was gobbled up by the quick-swimming dolphin when it hit the water.

August 4

1948—Coast Guard Day Celebrated at Hatteras

North Carolina governor R. Gregg Cherry joined 2,500 celebrants at the Cape Hatteras Lighthouse for Coast Guard Day activities marking the 158th anniversary of the service. The day began with dignitaries and speeches, followed by a picnic lunch hosted by residents of Hatteras Island's seven villages. In the afternoon, air-to-sea rescue demonstrations, a surfboat race and a concert by the Elizabeth City High School Band entertained the crowd. The Cape Hatteras Lighthouse was decorated with colorful signal flags strung from a rope from the top of the spire to the bottom. It presented a delightful scene.

Coast Guard Day celebrated at the Cape Hatteras Lighthouse. *North Carolina Department of Conservation and Development, State Archives of North Carolina, 1948.*

August 5

2001—Historic Shipwreck Goes Up in Smoke

While investigating an early morning beach bonfire at Coquina Beach, National Park Service ranger Michael Ice noticed an especially large piece of wood burning in the flames. After questioning two young men at the fire about where they had procured the wood, Ice learned that the fire-starters had inadvertently burned a portion of the shipwrecked schooner *Laura A. Barnes*, which came ashore in 1921. The young men, who were visiting the area from Pennsylvania, were charged with a misdemeanor: disturbing a cultural resource. Had the shipwreck been over one hundred years old, the culprits could have been charged with a felony. Rangers said it was not the first time the *Laura A. Barnes* suffered damage from a bonfire.

August 6

1918—Lightship Sunk by German Raiders

As part of Germany's plan to disrupt commerce on America's eastern coast, the Diamond Shoals Lightship No. 71, anchored off Cape Hatteras to warn ships of the treacherous shoals, was torpedoed by a submarine and consequently sank. The crew of twelve escaped injury and rowed ten miles to shore in a small boat. The submarine was later spotted a half mile off the North Carolina shore. It was believed the U-boat that took down the lightship was the same vessel that had sunk the steamer *O.B. Jennings* days earlier. The lightship was quickly replaced with another that was kept as a spare.

August 7

1895—Hatteras Crews Right Edenton Vessel

The two-masted schooner *Rosa B. Cora*, of Edenton, North Carolina, capsized in the Pamlico Sound during an early morning squall. The ship, en route to Rodanthe from Elizabeth City, carried a load of ice, flour, corn and salt. The captain of the vessel, William R. Balance, requested assistance from the Chicamacomico Life-Saving Station after he was taken to Rodanthe in a shad boat that the *Rosa B. Cora* had in tow. The Chicamacomico crew, assisted by crews from the New Inlet and Pea Island Stations, was unable to raise the schooner for two days due to rough conditions in the sound but was successful on the third day when the water calmed. The ship was righted, bailed out and towed to a safe harbor, where the owner thanked the crew for its assistance.

August 8

1950—Tar Heel Writers Converge on Roanoke Island

The University of North Carolina Press sponsored a Writers Conference on Roanoke Island that was attended by dozens of North Carolina authors. Following a luncheon meeting held at the Roanoke Inn, the group met again at Seatone, the sound-side estate of Onslow and Mabel Evans Jones. Inglis Fletcher of Edenton, author of several historical fiction books about early colonization in North Carolina, presided over the afternoon session. The authors were treated to a special evening performance of *The Lost Colony*. In attendance were Betty Smith, Jonathan Daniels, Paul Green, William Meade Prince and LeGette Blythe.

August 9

1937—Wildlife Officer Encourages
Kitty Hawk Preserve

Game warden J.W. Hobbs went on record as supporting a plan to designate Kitty Hawk Woods as a deer preserve. Although the deer population suffered from overhunting, Hobbs believed that with current game laws and slight restocking, the species could rebound. The proposal was presented by State Game and Inland Fisheries commissioner J.D. Chalk. Fifteen years later, because hunting had caused the herd to become too small, deer were reintroduced to the area. Today, portions of the maritime forest south of the U.S. 158 Bypass in Kitty Hawk are administered by the North Carolina National Estuarine Research Reserve program. Hunting is allowed on a limited basis.

August 10

1942—Civil Air Patrol Operations Commence

Flying from a Spartan landing field at Skyco on Roanoke Island, the first patrol from Coastal Air Patrol Base 16 was launched. Base 16, which later moved to an airport north of Manteo funded by the Works Progress Administration, was North Carolina's first Civil Air Patrol (CAP) base. The CAP was made up of civilian pilots who greatly aided the military by logging hundreds of hours of flight time patrolling the coast from Norfolk to Ocracoke Inlet to protect shipping and act as lookouts for German U-boats.

August 11

1909—New Distress Call Used Off Hatteras

The first SOS call was issued by wireless operator T.D. Haubner of the SS *Arapahoe* when he radioed for assistance after the vessel's propeller shaft broke in two off Cape Hatteras. Prior to the use of SOS, the signal for a ship needing assistance was CQD. The CQ (from the French *securité*) meant "listen up" or "pay attention." A CQ call was issued so that all stations were called at one time. The D was later added for distress; thus, a CQD message meant "All Stations: Distress." Both signals were used for a time until SOS became the standard distress signal.

August 12

1990—Women's Fishing Tournament Begins

The inaugural Alice Kelly Memorial "Ladies' Only" Billfish Tournament took place in the waters off Oregon Inlet. The contest was a tribute to Alice Kelly, founder of the Outer Banks Cancer Support Group. After being diagnosed with Hodgkin's disease, Kelly discovered that transportation to doctors' offices and hospitals was difficult for area residents. Kelly loved offshore fishing and encouraged women to explore the sport that brought her so much joy. The tournament, held each August, continues to be an annual event and a fundraiser for the Outer Banks Cancer Support Group.

August 13

1981—Pennsylvania Legislator Injured in Hang Glide Mishap

Richard Geist, a member of the Pennsylvania House of Representatives, was injured while hang gliding during a family vacation in Nags Head. After taking off in a motorized hang glider, Geist's motor stalled, causing him to fall twenty feet to the ground. The Altoona resident sustained injuries to his right hand and ankles and was taken to Albemarle Hospital in Elizabeth City, where he was treated for a broken ankle and several smaller broken bones near that joint. The thirty-six-year-old Republican was then flown to Durham, North Carolina, where he underwent surgery at Duke University Medical Center.

August 14

1941—Sheriffs Fêted in Dare

Approximately two hundred delegates attending the North Carolina Sheriff's Association meeting in Elizabeth City traveled to Dare County to attend a fish fry at Fort Raleigh, a bathing beauty contest in Nags Head and then to see a performance of *The Lost Colony*. The beauty contest was held at the Nags Head Beach Club and was organized by the club's manager, Humpy Deans. Wake County's Vivian Bradshaw was crowned queen and won the first place prize of fifteen dollars, while Bertie County's Catherine Spruill and Dare's Lavina Meekins placed second and third and won ten and five dollars, respectively. Sheriff D. Victor Meekins acted as host while the law enforcement agents and their spouses were in Dare County.

August 15

1949—Entertainer Mobilizes to Aid Outdoor Drama

Bandleader Kay Kyser, while vacationing in Nags Head, called a community meeting to discuss the future of *The Lost Colony*. Kyser, who had taken an interest in the drama, which was celebrating its ninth production season, believed that the success of the show would take an entire village and was hoping to generate ideas to put the show on more stable financial footing. The gathering was held at the Dare County Courthouse, with Kyser acting as master of ceremonies. Kyser continued supporting *The Lost Colony* for many years and was always looking for ways to attract new audiences with promotions such as Celebrity Night.

August 16

2002—Longest Bridge in State Is Dedicated

Following speeches and a ribbon cutting, Andy Griffith and North Carolina governor Mike Easley, accompanied by their wives and riding in Griffith's convertible antique automobile, led the procession across the new Virginia Dare Memorial Bridge. Participating in the

Inaugural trips across the Virginia Dare Memorial Bridge. *Drew C. Wilson Collection, Outer Banks History Center, 2002.*

historic first crossing were municipal and county delegations, Elizabethan interpreters, antique autos and motorcycles in the westbound lanes, while walkers and bike riders crossed in the eastbound lanes. The new bridge connected Roanoke Island with Manns Harbor on the mainland. The 5.2-mile, four-lane span became the longest bridge in North Carolina. Hundreds turned out to celebrate the dedication of the new structure despite searing August heat.

August 17

1861—Confederate Privateer Prowls Off Hatteras

The British vessel *Andover*, sailing off Cape Hatteras, was boarded by men from a privateer described as a two-hundred-ton side-wheel riverboat with one stationary and one pivotal gun. The vessel bore no name, but the crew reported having taken two prizes and announced that it, along with two other ships, planned to attack a Federal warship. Within two weeks, U.S. ships sailing under the direction of Commodore Silas Stringham would land troops at Hatteras Inlet under the command of General Benjamin Butler to ease the growing problem of privateering.

August 18

1587—First Child of English Parentage Born in New World

Virginia Dare was born on Roanoke Island to parents Ananias and Eleanor White Dare, members of the Roanoke Voyage of 1587, sent to establish an English foothold in the New World. Baby Virginia held the distinction of being the first child of English parents born in America. Virginia's artist grandfather John White was governor of the colony and returned to England for supplies but was forbidden to return until 1590. By then, the colony had disappeared. Virginia Dare became the basis of many stories and legends and is the namesake of Dare County.

August 19

1977—Unpainted Aristocracy Noted on Historic List

The Nags Head Historic Row Cottage District was added to the National Register of Historic Places, a federal list of properties deemed worthy of designation and preservation. Sixty cottages were included in the district that runs along the Beach Road from Jockey's Ridge to the Whedbee Cottage three miles south. The cottages, with their characteristic pitched roofs, cedar shake siding, shuttered windows and wraparound porches were summer homes for Nags Head's earliest beachgoers. Many of the oceanfront homes have been passed down through the generations. They were dubbed the "Unpainted Aristocracy" by newspaperman Josephus Daniels for their unassuming yet stately appearance.

August 20

1924—Lifesavers Honored for Mirlo Rescue

Captain John Allen Midgett and surfmen Zion S. Midgett, Arthur V. Midgett, Leroy S. Midgett, Clarence E. Midgett and Prochorus L. O'Neal of the Chicamacomico Coast Guard Station were awarded the Gold Lifesaving Medal for the August 1918 rescue of crewmen from the British ship *Mirlo*. Bound for Norfolk with a load of gasoline and oil, the *Mirlo* struck a mine near Wimble Shoals, igniting an inferno on the ocean's surface. The crew responded in its power lifeboat, challenged by high seas, smoke, flames and wreckage. It rescued forty-two men from the perilous scene.

August 21

1993—Preservation Group Receives Land

State senator Marc Basnight presented a deed for six undeveloped acres of land surrounding the Chicamacomico Life-Saving Station at Rodanthe to Michael Halminski, president of the Chicamacomico Historical Association. The land was a gift from retired oilman Walter R. Davis and his wife, Joann, of Southern Shores. The parcel was valued at $500,000 and would be left in a natural state. The gift of land was not the first time the Davises aided in the preservation of the Chicamacomico Station. The couple purchased the station in 1978 and donated it to the association. The historic site is one of the best examples of a lifesaving station because of the number of structures still intact.

August 22

1971—Kids Ride in Limousine When Governor Visits Ocracoke

North Carolina governor Bob Scott landed on Ocracoke Island after stops in Rodanthe, Avon, Frisco and Cape Hatteras. Scott arrived via the ferry *Alpheus W. Drinkwater*, which he helped pilot. While visiting, Scott hoped to do a little fishing. The state's chief executive was traveling in his big black limousine adorned with the No. 1 license plate. As a creative goodwill gesture, Scott offered children rides in the limo during his stops along way. Any takers were awarded with a certificate of proof of their brief sojourn with the governor that declared them members of the No. 1 Riders Club. Statewide, four hundred children rode in the limo while Governor Scott talked with their parents.

August 23

1930—Trip to Beach Turns Tragic

Claude G. Gardner of Washington, North Carolina, was mortally injured while riding to the beach at Ocracoke. Gardner sustained a serious back injury and later died in a Beaufort County hospital after the open truck in which he was riding hit a divot. Also injured was popular congressman Lindsay C. Warren, who sustained a broken arm in the incident. Both men, guests of the Pamlico Inn, which provided the truck service to the beach, were taken to "little" Washington aboard the Coast Guard cutter *Pamlico*.

August 24

1941—Radio Pioneer Honored on Roanoke Island

A ceremony honoring Canadian radio pioneer Reginald Aubrey Fessenden took place on Roanoke Island at the site where, in 1902, he was the first to transmit the human voice via wireless technology. Local promoters wished to draw attention to Fessenden's work, which would bolster the theme of Dare County as the "Land of Beginnings." J. Melville Broughton, governor of North Carolina, attended the event but admitted to reporters that he hoped to spend some time fishing on his trip. While the governor and officials were in Dare County, a press release was issued by the North Carolina State News Bureau claiming that a bridge would be built across the Croatan Sound and would be named for Reginald Fessenden. It would be more than fifteen years before a bridge named for North Carolina governor William B. Umstead was built to connect Roanoke Island and the mainland.

August 25

1941—Broughton Is First Governor to Drive to Hatteras

North Carolina governor J. Melville Broughton visited Hatteras Island and greeted a crowd of one thousand

North Carolina governor J. Melville Broughton delivers a speech on the steps of the Cape Hatteras Lighthouse. *D. Victor Meekins Collection, Outer Banks History Center, 1941.*

people at the Cape Hatteras Lighthouse. Broughton pleased the crowd when he announced plans to abolish the toll on the Oregon Inlet ferry, a first step to making Hatteras Island more accessible. Broughton was purported to be the first governor to visit the isolated outpost via motorcade and experienced the challenges of island living firsthand when his car became lodged in the sand. He and his entourage were photographed pushing the immobile automobile. These photos would later be useful to illustrate the need for a paved road on Hatteras Island.

August 26

1957—Dutiful Submarine Cheats Scrap Pile

The twenty-two-year-old submarine USS *Tarpon* that sunk nine Japanese merchant ships in the Pacific during World War II sank thirty-five miles off Cape Hatteras. The *Tarpon* had been sold for scrap and was being towed from New Orleans to Baltimore by the tugboat *Julia C.* A Coast Guard spokesman reported, "We think the gal just wanted to go to a water grave instead of the junk yard."

August 27

1973—Historic Ship Located Off Hatteras

Researchers from Duke University Marine Laboratory, Massachusetts Institute of Technology, *National Geographic* and the North Carolina Department of Cultural Resources discovered the ironclad USS *Monitor* in 230 feet of water sixteen miles southeast of Cape Hatteras on the last scheduled day of their joint expedition aboard the RV *Eastward*. The finding prompted an additional three days of data collection. The discovery took months to confirm, and the significant underwater archaeological find was not announced until the following year. The *Monitor*, famous for its battle with the CSS *Virginia* (formerly the USS *Merrimac*) in March 1862 at Hampton Roads, sank while being towed rounding Cape Hatteras on New Year's Eve 1862, with the loss of sixteen crewmen.

August 28

1861—Federal Troops Land at Hatteras Inlet

In an amphibious assault led by General Benjamin Butler and Flag Officer Silas Stringham, Union ships fired on Forts Clark and Hatteras, and Federal troops were landed. The goal of the expedition was to take the forts and gain control of Hatteras Inlet, which had been a favorite venue for Confederate privateers. Command of the inlet was a foothold to gaining access to eastern North Carolina and a backdoor water route to Norfolk, Virginia. The following day, Colonel William S. Martin surrendered. The victory provided a morale boost for the Union, which had recently suffered a great loss at the First Battle of Bull Run.

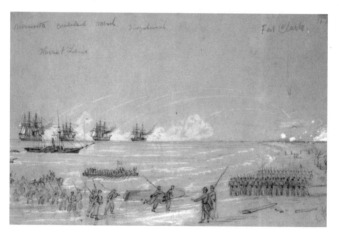

Landing of Union soldiers near Hatteras Inlet, August 28, 1861. *Sketch by Alfred A. Waud, Library of Congress, 1861.*

August 29

1937—Granite Marker Marks FDR's Roanoke Island Trip

A monument commemorating President Franklin D. Roosevelt's visit to Roanoke Island and viewing of *The Lost Colony* eleven days earlier was unveiled and dedicated in an afternoon ceremony at Waterside Theater. Congressman Lindsay C. Warren presided over the event, and Josephus Daniels, U.S. ambassador to Mexico, gave the address. D.T. Singleton Monuments in Elizabeth City designed and carved the memorial that was unveiled by Natalie Etheridge and Roger Quentin Bell, young natives of Roanoke Island with ties to *The Lost Colony*.

August 30

1995—Dare Deputy Denies Drowning

W. Kevin Duprey, with the Dare County Sheriff's Department, responded to a dispatch about a swimmer in trouble three hundred yards off the beach at Pea Island. The quick-thinking deputy, whose former job was operating rescue boats in the Coast Guard, borrowed a boogie board from a beachgoer and entered the water. Being familiar with waves and rip currents, he located a break in the sand bar, or "out suck," and used its power to get him to deeper water quickly. After locating the swimmer in trouble, he helped the thirty-nine-year-old to shore. Duprey was later presented the Silver Lifesaving Award by the U.S. Coast Guard and the Governor's Award for Heroism and Bravery by North Carolina governor Jim Hunt.

August 31

1886—Charleston Earthquake Felt at Hatteras

A major earthquake centered near Charleston, South Carolina, rocked the Southeast just before 11:00 p.m. and was felt as far away as Boston, Chicago and the Caribbean. The keeper of the Cape Hatteras Lighthouse reported that the tower "would sway backward and forward like a tree shaken by the wind" and that the spire swayed from southwest to northeast. The seismographic event was estimated to be around seven on the Richter scale.

September 1

1900—Icon Begins Telegraphy Career

Alpheus W. Drinkwater was hired as a telegraph operator in Currituck. The Dare County native later moved to Manteo and made his career tapping out messages of storms, shipwrecks and other news along the Outer Banks. In 1908, Drinkwater sent the news of the Wright brothers' additional experiments in aviation. During his forty-year career, he was a well-known, trusted

Alpheus Drinkwater at his desk at the telegraph office. He worked as a telegrapher for forty years. *Photo by John Hemmer, North Carolina Conservation and Development, Travel and Tourism Division, State Archives of North Carolina, 1944.*

ambassador for the Outer Banks and was relied upon as a credible source; therefore, he was contacted when critical information from the coast was needed. A vessel in the North Carolina Ferry System bearing his name was dedicated in 1971.

September 2

1899—Boat Floated at Ocracoke

The schooner *Anna Bell* ran aground while trying to enter Ocracoke Harbor. The crew of the Portsmouth Island Life-Saving Station responded to the stranded vessel and took the master of the ship to Ocracoke, where he enlisted a lighter or smaller vessel on which to unload cargo. When the goods were removed from the stranded ship, it immediately became buoyant.

September 3

1990—Solar Aircraft Flies Cross Country

Eric Raymond in his solar airplane Sun Seeker poses for photos following his cross-country flight. *Drew C. Wilson Collection, Outer Banks History Center, 1990.*

The first coast-to-coast airplane trip in a solar-powered craft ended at a Currituck County turf farm near Spot. Thirty-three-year-old pilot Eric Raymond had hoped to land at Kill Devil Hills, but strong winds and low visibility prevented it. Two days later, Raymond trailered his ultra-light aircraft Sun Seeker to the Wright Brothers Memorial, where he posed for photographs and signed autographs. Raymond, who logged over 2,400 miles on his thirty-two-day journey, said he hoped his feat would draw attention to alternative energy sources. Weighing less than two hundred pounds, Sun Seeker was propelled by a two-horsepower engine fed by seven hundred solar cells.

September 4

1977—County Officials Don't Cotton to Extra Heat

Six North Carolina State Highway patrolmen were assigned to duty in Dare County over the Labor Day weekend at the request of the North Carolina Department of Crime Control and Public Safety. The troopers aided four local law enforcement officers with the influx of holiday traffic. Statistics showed an increase of accidents during the summer months and around holidays. At odds were local tourism and hospitality interests versus state safety interests. The Dare County commissioners, some of whom owned businesses that catered to tourists, later sent a letter of opposition about the bolstered police presence.

September 5

1923—Air Power Shown at Hatteras

U.S. Army general and aviation pioneer William "Billy" Mitchell proved his theory that battleships at sea were vulnerable to attack by aircraft. The navy anchored two obsolete vessels, the USS *Virginia* and the USS *New Jersey*, off Cape Hatteras. The first round of airplanes flew from Langley Field near Hampton, Virginia, thus proving long-range attacks were possible. The second group of aircraft took off from a temporary airstrip constructed at Hatteras. While observers, including navy brass, watched from the navy vessel *St. Mihiel*, which was anchored close by, both the *Virginia* and the *New Jersey* were easily sunk. Mitchell's experiments, however, did not convince some of his superiors of the threat of air power to ships on the sea. Mitchell was later court-martialed for his outspokenness and for criticizing his superiors. Known as the Billy Mitchell Wrecks, the *Virginia* and *New Jersey* rest in the Graveyard of the Atlantic and are popular diving sites.

September 6

1937—Inaugural Season of Lost Colony Ends with Dinner

As an expression of gratitude for their contributions for making the 350th anniversary of the birth of Virginia Dare a success, the Roanoke Colony Memorial Association hosted a late-night, end-of-season dinner for *The Lost Colony* cast and crew at the close of the show's first summer run. The meal featured cold turkey, chilled asparagus tips, sliced tomatoes, potato salad, sweet mixed pickles and cake and ice cream for dessert. A written statement on the program correctly predicted that the "glory of your achievement will gain added lustre through the years."

September 7

*1952—Sadie Hawkins Day at Leary's Bingo
Draws Crowd*

Leary's Bingo, located across from the Nags Head Fishing Pier, celebrated its fourth-annual Sadie Hawkins Day. The action began at noon when the first game of Bingo was played. Prizes for the special occasion, which had grown in popularity over the years, included luggage, a boat motor, a bicycle, kitchen appliances and other swag. The event drew gamers from across eastern North Carolina and Virginia. The final prize of the day was a General Electric television. Double cards were only ten cents.

September 8

1932—Teen's Manteo-to-Murphy Flight Postponed

A seventeen-year-old aviator from Kinston, North Carolina, had his plans to fly cross-state put off a day because of high winds. John Parrott flew from Kinston to Manteo with his father, stopping in "little" Washington along the way to pick up newspaperman Carl Goerch. After spending the night at the Fort Raleigh Hotel, the trio took off from Nags Head the next day. Because of the early morning departure, few were on hand to see the group off. Following a fuel stop in Charlotte, they flew over Murphy in the westernmost section of the state and dropped a letter from the mayor of Manteo to the mayor of Murphy and a gift of grapes and figs representing the eastern part of the state.

September 9

1932—New York Couple Towed to Manteo

A newlywed couple from New York honeymooning on their yacht, *Highball*, were rescued by the Coast Guard after being stranded for a day at the mouth of the Alligator River at a place called Great Shoals. An unidentified man reported the mishap to the Coast Guard. Mr. and Mrs. Victor Crawford were towed to Manteo by a picket boat from Station Oregon Inlet following their twenty-four-hour ordeal. The bride and groom were en route to Wilmington via the Intracoastal Waterway as part of their honeymoon trip to Buenos Aires. They decided to stay in Manteo until repairs could be made to the *Highball*.

September 10

1942—Dare County Begins New School Year

After some last-minute filling of vacancies, a new school year began across the county with a full complement of teachers. Approximately 249 students were enrolled in Manteo School, 140 in the lower grades and 109 in the upper grades. New in 1942 was the addition of twelfth grade, in which two students were enrolled, with more expected to sign up. All recent high school graduates were allowed to attend. Manteo was the only school in the county with a lunchroom because of a large cut in funding from the Works Progress Administration, which provided for the service. Lunches were free to undernourished children (to be determined by a representative from the Child Welfare Department) and cost ten cents for others.

September 11

1971—Surfing Tradition Is Born

The Eastern Surfing Association (ESA) championship tournament, known as "The Easterns," was held for the first time at the Cape Hatteras Lighthouse. The two-day event drew one hundred surfers, more or less. Floridian Charley Baldwin took the top title for men, and New Jersey surfer Linda Davoli clenched the ladies' title. Mitch Kauffman was an ESA director from Florida for fifteen years and shared his remembrances of Hatteras during the 1970s. Although the competition during the day was intense, the campground camaraderie at night built lasting relationships. "The competitors used to camp out like Woodstock," Kauffman reminisced. Following Hurricane Irene in 2011, The Easterns were moved to Jennette's Pier in Nags Head.

September 12

1988—Charter Boat Recovers Body

Twenty-two miles off Oregon Inlet, an Oceana Naval Air Station–based F-14 Tomcat jet crashed in the Atlantic Ocean within sight of two vessels of the Oregon Inlet Fishing Center fleet. The charter fishing boat *Jo Boy II* picked up one of two crew members of the ill-fated aircraft. The pilot was airlifted by a Coast Guard helicopter but was later pronounced dead at Portsmouth Naval Hospital in Portsmouth, Virginia. The lost airplane, valued at $35 million, was attached to Fighter Squadron 143 at Oceana in Virginia Beach. It was practicing combat maneuvers at the time of the crash and sank almost immediately.

September 13

1900—Wright Assisted by Local Lad

Kitty Hawk teenager Elijah Baum greeted Wilbur Wright as he came ashore at Kitty Hawk and escorted the inventor to the home of William and Addie Tate. Wright and his brother, Orville, were interested in experimenting with human flight and went to Kitty Hawk at the encouragement of Postmaster Tate. A month prior to his arrival, Tate wrote to Wright describing "a stretch of sandy land, 1 mile by 5 with a bare hill in the center 80 feet high, not a tree or bush anywhere to break the evenness of the wind current."

September 14

1987—Red Wolves Allowed to Run Free Again

The gate on a 2,500-foot holding pen in the Alligator River National Wildlife Refuge was opened, allowing a pair of red wolves to roam free. The red wolves, declared extinct in the wild when the last remaining true species were captured in Louisiana and Texas in the late 1970s, were part of a reintroduction program and had lived in pens since arriving in North Carolina eight months earlier. U.S. Fish and Wildlife Service officials reported that by the end of the day, both wolves were still either in the enclosure or nearby—a good sign. Had the animals run immediately from the pen, they could have separated, which was not the desired outcome of this step in the project.

September 15

1933—She Sings Jazz to Lift Spirits

En route from Havana to New York, the luxury passenger ship *Morro Castle* was stranded off Cape Hatteras in a hurricane. The entire orchestra was seasick, and the ship's 140 passengers gathered in the lounge because of water in some cabins. Twenty-two-year-old Gwendolyn Taylor of Philadelphia distracted the crowd with piano playing and singing. "I thought I ought to do something," she later recounted, "and the only thing I could do was play. So I played. I sang, too; only cheerful things. I think some of the women wanted to hear hymns, but I thought they needed jazz more."

September 16

1944—Coast Guard Rescues Their Own

U.S. Coast Guard Kingfisher planes from the Air Station Elizabeth City spotted survivors of the Coast Guard cutter *Jackson* and landed to administer first aid to the men who had been adrift at sea for fifty-eight hours. The *Jackson* and *Bedloe*, sister cutters, sank during the Great Atlantic Hurricane of 1944 while responding to the torpedoed ship *George Ade* off Cape Hatteras. Ironically, the *George Ade* was safely towed to Norfolk, Virginia, with no loss of life, while the shipwrecked men from the *Jackson* and *Bedloe* believed that the other cutter would come to their aid. In all, forty-eight men perished when the cutters were lost.

September 17

1861—Federals Blow Up Fort Ocracoke

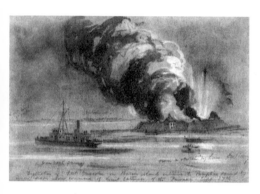

Destruction of Fort Ocracoke. *Library of Congress Collections, 1861.*

An expedition led by U.S. Navy Lieutenant Eastman aboard the *Pawnee* sailed to Ocracoke Inlet and destroyed Confederate Fort Ocracoke on Beacon Island near the entrance to the Pamlico Sound. The ships *Susquehanna* and *Tempest* went to assist, but they drew too much water to enter the sound. The tug *Fanny* was able to anchor a mile away and sent a landing party in a small boat. The fort had been abandoned by Rebel forces, who managed to remove two eight-inch guns, which they took to New Bern. All remaining ordnance was destroyed, and the fort was set afire. It was said the blaze was so bright that it could be seen for thirty miles. The Yankees reported that Fort Ocracoke was one of the largest Rebel forts along the coast and would easily have been defended since large boats could not approach it. However, after the loss of Forts Hatteras and Clark, the Southern troops were skittish and fled.

September 18

1985—Nine-Foot Gator Killed on Mainland

A wounded alligator was discovered in a canal adjacent to U.S. 264 in the Alligator River National Wildlife Refuge on the Dare County mainland. The nine-foot reptile was shot in the side with two arrows. Attempts to capture it before it died were unsuccessful. The alligator had been observed by area residents who had gotten to know its habits and comings and goings. The body was picked up by refuge officials and taken to Benny's Seafood in Manns Harbor, where it was stored overnight. The following day, it was taken to a Chesapeake, Virginia taxidermist. The alligator was mounted and now can be seen at the North Carolina Aquarium on Roanoke Island. Area residents expressed dismay and disgust at the senseless killing of such a magnificent creature. "What kind of fool would do this?" asked a Mann's Harbor resident, while an East Laker likened it to having someone sneak into your yard and shoot your dog.

September 19

1987—Beach Cleaners Find Medical Waste

Participants in the statewide litter collection event Beach Sweep '87 came across discarded medical supplies at the Pea Island National Wildlife Refuge, south of the Cape Hatteras Lighthouse and on New Hanover County's Masonboro Island. The items collected included syringes and vials of what appeared to be blood. While none of the medical waste cleaned from Dare County beaches was saved, the items found on Masonboro, enough to fill half a trash bag, were handed over to the Wrightsville Beach Police, who planned to pass them along to the State Bureau of Investigation.

September 20

2005—Walmart Employee Narcs Out Civics Student

The Secret Service visited Currituck County High School in Barco and confiscated a poster created for a civics assignment. The student who made the poster wanted to illustrate the right to dissent and took a photograph of his hand in a thumbs-down position next to a photograph of George W. Bush that was affixed to a wall with a red tack through the president's head. A zealous employee in the Kitty Hawk Walmart photo lab where the film was taken for processing contacted the Kitty Hawk Police Department, which referred the case to the Secret Service. The teacher who assigned the project described the incident as ridiculous.

September 21

1933—North Beach Fishermen Make Great Haul

While the fishing season was just underway, fishermen from the village of Duck made the largest single-day catch of the year when their nets collected twenty-five thousand fish or twenty-five boxes of fresh catch. The haul was chiefly made up of spot, which was marketed by local buyers Whitson and Rogers, who handled all catches from the village. The Duck fishermen were fortunate in that their nets were not set during the fierce hurricane the week prior when most fishermen on Hatteras Island and at Stumpy Point on the Dare mainland had their nets washed away.

September 22

1997—SandyDuck Data Collecting Summit Begins

Billed as the "world's largest coastal field experiment," SandyDuck took place at the Army Corps of Engineers Field Research Facility in Duck. The event, which began on this date, drew scores of scientists from around the nation, Canada and Great Britain for a six-week research-collecting extravaganza. In addition to the Army Corps of Engineers, SandyDuck was sponsored by the Office of Naval Research and the U.S. Geological Survey. Universities, government agencies and private industry sent representatives to participate in the gathering, which focused on sediment movement. The list of measuring devices read like an oceanographer's dream and included acoustic devices, video cameras, current meters, a wide variety of sensors, sonar and radar systems, along with other state-of-the-art sensing systems. The event, which took seven years to plan, was held in September and October just after the peak of hurricane season and at a time when early nor'easters are known to form.

September 23

1958—International Students Wrap Up
Trip to Manteo

After spending the night at the Manteo Motel, a group of international students ranging in age from twenty to twenty-seven departed Roanoke Island and continued their travels, heading to Washington, D.C., and New York City. While in Manteo, they viewed the historical attractions, visited local schools and businesses, enjoyed a meal at Walker's Diner downtown and were treated to an impromptu reception at the home of Mr. and Mrs. Keith M. Fearing Jr., hosted by the Fearing family. The touring group visited after receiving an invitation from the Manteo Rotary Club. The young people represented Belgium, Switzerland, France, Holland, Germany and Greece.

September 24

1969—Suit Filed Against Carolinian Anchor Room

The U.S. Justice Department filed a suit against the Anchor Room, a club operating at the Carolinian Hotel in Nags Head. In question was the Anchor Room's violation of the Civil Rights Act of 1964 by not serving black customers on the same basis as white customers, charged Attorney General John N. Mitchell. The Anchor Room was a public facility and not, as management purported, a private club; therefore, by law it should have accommodated black and white patrons equally. The suit was filed in U.S. District Court in Elizabeth City, North Carolina.

September 25

1960—Overturned Boat and Dog Found Near Inlet

Manteo's Balfour Baum alerted the Coast Guard via radio after he discovered a capsized boat in Pamlico Sound. The small boat had been trailered to Oregon Inlet by a couple from St. Joseph, Missouri, who was visiting family in Elizabeth City. The man and woman from the Show Me State had launched the fourteen-foot boat, which was seen in precarious spots in the inlet by two local men, each of whom warned the couple of the dangerous nature of the inlet's tides, shoals and currents. At the time Baum found the boat, the couple's dog was sitting on top of the small vessel. Their car and trailer were parked on shore.

September 26

1896—Small Boat Capsizes on Bar

The Merritt Wrecking Company had dispatched the wrecking steamer *William Conley* to free the vessel *DeBarry*, which had run aground off Kitty Hawk. Eight men from the *Conley* boarded a small boat and headed to shore when the vessel stuck on a sandbar. A wave then rolled over the bar and capsized the boat, dumping its passengers in the ocean. Surfman Daniel W. Hayman of the Kitty Hawk Life-Saving Station witnessed the capsizing from the beach. He grabbed a piece of rope from the recovered goods from the *DeBarry* and tied one end around his waist and handed the other end to someone on the beach. Hayman, in actions that were described as showing "great coolness and courage," then waded into the water and rescued seven of the eight men. The eighth man drowned, and his body was recovered three days later by members of the Whales Head Station. After the master of the steamer was notified, a coffin was built, and the body was buried west of the high tide line.

September 27

1930—Wright Memorial Bridge Opens to Traffic

After six months of construction by the W.L. Jones Company of Elizabeth City, the Wright Memorial Bridge between mainland Currituck County and Kitty Hawk opened for traffic. The final cost for the three-mile span topped $225,000. At high noon, an eight-car procession led by officers of the Wright Memorial Bridge Company made the trip across the wooden span that greeted beachgoers with an arch at the east end, announcing that Dare County was both the Birthplace of a Nation and the Birthplace of Aviation. The first person to purchase a ticket to cross the bridge was Elizabeth City's Frank Dawson. Over the next ten days, more than one thousand cars crossed the bridge.

September 28

2009—Lighthouse Darkened for Four-Year Repair

The light was extinguished on the Bodie Island Lighthouse south of Nags Head. Built in 1871, the 156-foot tower needed major renovations, including repair to ironwork, restoration of the marble floor in the oil house, painting and window replacement. Congress approved over $3 million for the renovation project, but work was halted in 2011 when it was determined that structural damage was much greater than initially estimated. After an additional $1.89 million in funding was allocated, work resumed in March 2012. On a picture-perfect Outer Banks evening, April 18, 2013, the Bodie Island Lighthouse beacon signal was restored before a crowd of descendants of Bodie Island lighthouse keepers, historians, politicians, lighthouse enthusiasts, caring citizens and National Park Service personnel.

September 29

1992—Wanchese Youth Airlifted After Snakebite

While bow hunting near the Dare County Bombing Range, two young men got their truck mired in mainland mud. While attempting to dig out the back tires, one of the fellows had his hand bitten by a poisonous copperhead snake. In a valiant effort to assist his buddy, the other young man ran three miles to the communications tower, where a call for aid was dispatched. The injured young man, a senior at Manteo High School, walked two miles to the intersection of Highway 64 and Highway 264 and was picked up and taken to the Mann's Harbor Community Building, then airlifted to Albemarle Hospital in Elizabeth City. There, he underwent surgery for the snakebite.

September 30

1861—Yankee Soldier Makes Sketches on Hatteras Island

Charles F. Johnson, a Minnesota Swede and soldier with the Ninth New York stationed at Hatteras, obtained a pass, explored the island and created some sketches. He wrote in his diary that he made seven sketches of rural scenes during his "ramble" and discovered a "strange musty sort of beauty" in his new environs. Johnson also noted that "everything on the island is devoid of paint—dwellings, barns and windmills, of which the latter there are a greater number than I supposed were in existence in the whole country." Johnson's diary was published in 1911 as *The Long Roll: Being a Journal of the Civil War Set Down During the Years 1861–1863*.

October 1

1872—Third Bodie Island Lighthouse Lit

The black-and-white-banded Bodie Island Lighthouse was illuminated for the first time. Equipped with a first-order Fresnel lens, the beacon beamed a fixed white signal visible for eighteen nautical miles. The 156-foot spire replaced two earlier lighthouses in the same vicinity. The original 1848 Bodie Island Lighthouse became obsolete shortly after its completion due to a faulty foundation. Another lighthouse was built in 1859 that was used as a lookout by Confederate troops during the Civil War. They later blew it up prior to retreating. The new lighthouse and associated outbuildings were completed at a cost of $140,000.

October 2

1972—Surfers Represent

More than a dozen surfers attended a meeting of the Nags Head Board of Commissioners to voice opposition to a recently adopted town ordinance that limited surfing to the periods between dawn to 9:00 a.m. and 6:00 p.m. to sunset. The restriction would be in effect only from May through September. While concerned for the safety of swimmers, town officials were receptive to feedback from the surfing community and suggested they organize, accept responsibility and work cooperatively toward mutual goals. The wave riders were described as "garbed in attention-attracting clothes" and ranging in age from "that period of a full head of hair—some uncontrolled—to a status of beginning baldness."

October 3

1970—Dare County and Cape Hatteras Lighthouse Mark 100 Years

North Carolina governor Bob Scott waves to the crowd from his car in the parade that marked the opening of the Dare County–Cape Hatteras Lighthouse Centennial. A costumed celebrant returns the salutation. *Aycock Brown Collection, Outer Banks History Center, 1970.*

The weeklong Cape Hatteras Lighthouse–Dare County Centennial celebration began on this day with a parade in downtown Manteo. North Carolina governor Bob Scott took part in the procession, riding in a convertible with W. Stanford White Sr., chairman of the Dare County commissioners. The parade was followed by a fish fry, boat races, a street dance and the debut of the pageant *Dare of Tarheelia*, which would run an additional five nights at Waterside Theater. Ola Austin reigned as Centennial Queen. The final day of the celebration included declaring the winner of the beard-growing contest, with the champion winning a free shave at Manteo's Reynolds Barbershop.

October 4

1864—Confederates Darken Screwpile Light

The Croatan Light, also known as Caroon's Point Light, was destroyed by the Rebel raiders on the Confederate ironclad *Albemarle*. The screwpile light, located at the confluence of the Albemarle and Croatan Sounds, was blown up and then set on fire in order to thoroughly destroy it. A one-and-a-half-story "cottage-style" screwpile lighthouse equipped with a fourth-order Fresnel lens was built to replace the old beacon. It was completed in 1887.

October 5

1951—Airport Managers Meet in Dare

A group of airport managers from several southern states had lunch at the Carolinian during the second day of their three-day meeting. Manteo's Melvin Daniels acted as host of the luncheon and used the event to highlight the work of the Kill Devil Hills Memorial Association and its efforts to commemorate the Wright brothers' first flight each December 17 at the memorial. The following day, David Stick, who would later publish several important works on Outer Banks history, pitched the idea of building a museum at the Wright Brothers Memorial. His idea was well accepted, and the group agreed to sponsor the project and make a donation. Fewer officials than planned were able to attend because of foul weather, which prevented many distant managers from making the trip. While plans were for over one hundred participants, fewer than half came. Some events had to be cancelled. A fishing trip and an orchestra scheduled to play at the Nags Head Casino were called off.

October 6

1943—Governor Declares December 17 Kitty Hawk Day

North Carolina governor J. Melville Broughton issued a proclamation declaring December 17 as Kitty Hawk Day. The date was observed as the day when Orville and Wilbur Wright achieved flight in a heavier-than-air craft on the sands near Kitty Hawk, and 1943 marked the fortieth anniversary of the remarkable achievement. As Broughton put it, the anniversary would be "an epochal event" that would "come in the midst of the greatest war in history—a war in which the airplane will be the decisive implement of victory for democracy, decency and righteousness in the epochal struggle against aggression, brutality and slavery." In the proclamation, he urged North Carolinians, especially those involved in the airplane industry and the armed services, to "give suitable observance," if possible, and "where appropriate pay tribute" to Orville Wright and the memory of his brother, Wilbur.

October 7

1992—Fire Destroys Tiny Landmark Post Office

The small post office building in the tri-villages town of Salvo was destroyed by an early morning fire that law enforcement believed to be arson. The eight- by twelve-foot wooden structure was noted as one of the smallest post office buildings in the nation. The landmark was a favorite subject of photographs snapped by those traveling through the Cape Hatteras National Seashore. A temporary post office was set up in Rodanthe later that day, and an account was established at a local bank to raise funds to replace the ninety-year-old building.

October 8

1934—International Aviation Pioneers Fly Over Kitty Hawk

Prior to a meeting of the International Aeronautic Association, a group of aviation enthusiasts flew over Kitty Hawk and the site where Orville and Wilbur Wright made the first flight in a manned heavier-than-air craft. The distinguished delegation wanted to pay tribute to the late Wilbur Wright. French aviation pioneer Louis Bleriot, the first man to fly across the English Channel in a heavier-than-air craft, flew in the airplane of Rumanian prince Georges Bibeco, who was serving as president of the International Aeronautic Association. The Frenchman dropped a wreath over the Wright Memorial with the inscription "Louis Bleriot to Wilbur Wright."

October 9

1966—Frank Stick Art Show

The Carolinian Hotel hosted a one-day exhibition of Frank Stick paintings, the first time Stick's artwork had been shown publicly in North Carolina. Stick, a resident of Southern Shores, was a former illustrator whose work appeared in magazines such as *Sports Afield*, the *Saturday Evening Post*, *Outdoor America* and *Redbook*. He was drawn to the Outer Banks because of its fishing and hunting opportunities; vast, unspoiled beaches; historic attractions; and available land. He moved his family to the area in 1929 and was instrumental in the creation of the Cape Hatteras National Seashore. In all, twenty-seven paintings were shown. The exhibit overlapped with the Sixteenth Annual Nags Head Surf Fishing Tournament.

October 10

1997—Illegal Shrimp Confiscated

After receiving telephone calls about shrimpers too close to shore, the North Carolina Marine Patrol seized over three thousand pounds of shrimp from three trawlers found to be illegally fishing off the Outer Banks. Regulations prohibited shrimping within a half mile of shore between the Virginia line and Oregon Inlet. North Carolina Marine Patrol officials sold the seafood, worth over $8,000, to local dealers. The money was held by district court until the cases were tried. It was the largest collection of illegal seafood in eight years. Additional violations found on some of the ten trawlers boarded were undersized flounder and improperly installed bycatch-reduction devices. An upside to the event was that the Marine Patrol received calls asking for information about proper installation of the devices that let finfish pass through shrimp nets.

October 11

1934—CCC Camp Established

Civilian Conservation Corps Camp Virginia Dare was established on Roanoke Island, and the North Carolina Beach Erosion Control Project began. The young men stationed at Camp Virginia Dare aided in the task of sand fixation, which was undertaken by constructing brush fences and installing them along the contour of the ocean shoreline. The fences trapped sand and, in doing so, created dunes. In less than ten years, over three million feet of brush fencing was installed along the coast. Camp Virginia Dare was located near Mother Vineyard.

October 12

1891—Lifesavers Rescue Fishing Equipment

The crew of the Oregon Inlet Life-Saving Station aided a group of fishermen who had left their nets and equipment unattended in a small house near the beach. With an impending storm approaching, the surfmen moved the fishing gear to higher ground. It was fortunate for the watermen because the house washed away at the next high tide.

October 13

1953—International Aviators Visit

A group of international aviation pioneers from nine nations, led by Admiral Richard E. Byrd, flew over Kitty Hawk and Kill Devil Hills to retrace the steps of the Wright brothers. Following the air tours, the representatives from Belgium, Brazil, Canada, France, Mexico, Germany, Great Britain, Portugal and the Netherlands, who were flying in two helicopters, landed and lunched at the Carolinian Hotel in Nags Head. North Carolina congressman Herbert C. Bonner; Carl Goerch, chairman of the upcoming Golden Anniversary Celebration of the Wright brothers' first flight; and local aviation enthusiasts and historians joined them.

October 14

1980—Citizens Suggest Taxing Rental Homes

At a meeting of the Kill Devil Hills Board of Commissioners, a number of residents spoke in favor of enacting a tax on rental homes in that town. Past commissioner Diane Baum St. Clair suggested a fifty-dollar fee, which might bring in hundreds of thousands of additional taxes for Kill Devil Hills. It was St. Clair's opinion that vacationers used a large portion of the water consumed in the town. Another speaker reported that many cottages looked like motels with the large number of cars that filled up driveways. Following public comments, the board passed a motion to have town attorney Wally McCown investigate the possibility of taxing the rental homes.

October 15

2007—North Carolina Ferry for Sale on E-Bay

Bidding closed on an albatross of sorts—a custom-made passenger ferry that the state had purchased for over $275,000—that had been placed on the online marketplace E-bay. The vessel was purchased with the intent of ferrying children from the Currituck Banks to schools on the mainland. It turned out that there were few schoolchildren living in the Corolla area, although the brand-new ferry was built to carry fifty people. It also turned out that the boat was not as speedy as needed and was not suited for traversing the Currituck Sound. Enterprising Edentonians, upon learning of the ferry's fate, asked the state to donate it for tours around Edenton Harbor and up and down the Chowan River. Bidding on E-bay was to start at $200,000, but no worthy bids were placed on the unwanted ferry.

October 16

1995—Oden Completes Fifty Years of Service

Hatteras Islander Herbert L. Oden attended his final meeting on the board of directors of the Cape Hatteras Electric Cooperative. In Oden's longtime service, he was directly involved in bringing electricity to island residences and shops. He performed many tasks, including installing utility poles, stringing electrical lines, connecting homes to electrical power, keeping the electric plants operating, dealing with disgruntled customers and sending out billing statements. A new director to serve on the board was chosen at the following week's meeting, but no one could ever replace Oden and his service to the Hatteras Island community.

October 17

2009—WOBR Radio Alumni Hold Reunion

Former employees of radio station WOBR in Wanchese met for an afternoon of reconnecting and reminiscing at Pamlico Jacks Restaurant in Nags Head. A highlight of the afternoon was viewing old scrapbooks that held years of mementoes of activities such as building a float for the Manteo Christmas parade. Topics of conversation included how the radio industry had changed in recent years and the evolution of newspapers and the newspaper business. WOBR began broadcasting in the early 1970s on the FM frequency of 95.3 and the AM frequency of 1530. In the 1980s, the stations were known as Beach 95 and Beach Country. Since then, the FM station has also been known as the Rock, the Wave and, now, the Pirate.

October 18

1861—Confederate General Foresees the Future

After surveying the Albemarle and Pamlico Sound region, which he was charged with defending, Confederate general D.H. Hill wrote a report outlining his concern for North Carolina's vulnerable coast. Writing to S.R. Mallory, secretary of the Confederate navy, Hill explained, "Roanoke Island is the key to one-third of North Carolina and whose occupancy by the enemy would enable him to reach the great railroad from Richmond to New Orleans." He called for an additional four regiments and feared if Roanoke Island were captured, the inland towns of Elizabeth City, Edenton, Plymouth and Williamston would follow.

October 19

1906—Unknown Disaster at Sea

Cork life vests began to wash ashore between Cape Hatteras and Kinnakeet. During a two-week period, over four hundred made their way to Hatteras beaches. Some were identified and some were not. Those that were bore the markings "*Caswitz Rettunysyurcer, G.R.P.*," "*Sealanan*" and "*Smeskf.*" Along with the life vests, pieces of unmarked wreckage also washed ashore three miles to the north. Surfmen believed that because the life preservers washed up in such a short stretch of beach, and because of the large number of life vests, that had a wreck occurred, it was most likely a passenger ship close to shore. No maritime records corresponded with the names on the life preservers, and because no other traces of a wreck washed ashore, the incident remained a mystery.

October 20

1979—Hashish Beach

Dare County deputies collected more than two dozen inner tubes filled with between seven hundred and one thousand pounds of the drug hashish along area beaches. While the source of the inner tubes was unknown, Drug Enforcement Administration officials estimated the value of the substance at $1,600 a pound, while State Bureau of Investigation officers determined that the street value of the contraband could be as high as $2,500. Over a three-day period, civilian boaters, a research vessel and law enforcement helicopters aided in the roundup. It was thought to be the largest confiscation of hashish in North Carolina.

October 21

1953—Virginia Man Found in Fishing Net

A Hatteras Island fisherman was surprised when he found a dead body in his fishing net in Pamlico Sound. Coastguardsmen removed the body and, using papers found in the deceased's wallet, identified the man as John Willis, a rural mail carrier from Cape Charles on Virginia's Eastern Shore. Police had been searching for Willis, who was last seen in Norfolk on October 5, when he checked into a hotel. Although it was reported Willis was carrying a large amount of cash at the time of his disappearance, no money was recovered from the body.

October 22

1982—Griffith Speaker at Tourist Bureau Anniversary Banquet

The Dare County Tourist Bureau celebrated its thirtieth anniversary with a dinner at Nags Head's Seafare Restaurant. Approximately 250 people attended the affair and were treated to a keynote address by stage, screen and television star Andy Griffith. In his speech, the part-time Manteo resident praised several Dare Countians who had made contributions to the community. Those whom Griffith singled out were Eddie Greene, owner and founder of the Christmas Shop on Roanoke Island; David Stick, author of several books about local history; Marc Basnight, native and representative on the state board of transportation; and John F. Wilson IV, mayor of the town of Manteo, who was instrumental in the revitalization of that waterfront town. Also honored at the meeting was photographer and publicist Aycock Brown, who, since the Tourist Bureau's inception, had worked to promote the coast.

October 23

2009—Ferry Saves Five Triad Men

On an evening run between Cedar Island and Ocracoke, thirty-five-year veteran captain Donald Austin, aboard the ferry *Silver Lake*, spotted lights in the water. As the ferry approached, Austin saw five men in the sound. Three were clinging to a small, capsized boat, and a short distance away, two others were clutching Styrofoam to help keep them afloat. One of the *Silver Lake*'s rescue boats was launched, and two of the ferry's crew plucked the Burlington, North Carolina men from the sixty-degree water. Although the men were shivering, they were reported otherwise fine. Austin retired a few days later but had a memorable event to close out his career.

October 24

1911—Soaring Record Set by Wright

Orville Wright set a soaring record when he stayed aloft over Kitty Hawk for nine minutes and forty-five seconds. His achievement stood for almost ten years and was a touchstone for a modern era of soaring. It was estimated that during his ten-day stay on the Outer Banks, the

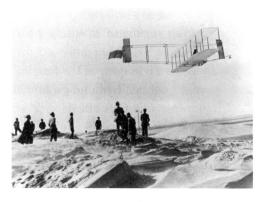

Orville Wright made soaring history when he remained aloft for more than nine minutes at Kitty Hawk. *Alpheus Drinkwater Scrapbook, Outer Banks History Center, 1908.*

aviation pioneer made ninety flights from Kill Devil Hill and West Hill. Wright was accompanied by his brother Lorin and his nephew Horace, as well as British aviator Alec Oglivie. This trip was the last of the Wrights' experiments at Kitty Hawk. Seven months later, Wilbur Wright died of typhoid fever.

October 25

1894—Soldiers Revisit Site of Battle

Two men who were soldiers with Hawkins's Zouaves, a New York regiment that participated in the Battle of Roanoke Island in February 1862, arrived at Skyco on the steamer *Neuse* during a tour revisiting old battlefields. Their accommodations were a room over the Daniels and Pugh General Store, and while they traveled about on the island the following day viewing the overgrown sites of the forts and the scene of the mortal wounding of O. Jennings Wise, one made the observation, "Everyone sails a boat here, even the babies, and whether white or black, there is no difference."

October 26

1990—Link to Hatteras Island Severed

During a fierce storm, the dredge *Northerly Isle* broke loose from its mooring in the early morning hours and struck the Herbert C. Bonner Bridge, knocking out a 369-foot section. After winds subsided, travel on and off Hatteras Island was limited to two ferry rides via Ocracoke Island until emergency ferry service was activated across Oregon Inlet. Cars waiting for a ferry off Ocracoke spent hours in a line that stretched to the National Park Service campground. Ocracoke residents rose to the challenge and brought hot coffee and other comforts to those stuck in the line of cars as many as six hundred long. The bridge was repaired and opened for traffic in February 1991.

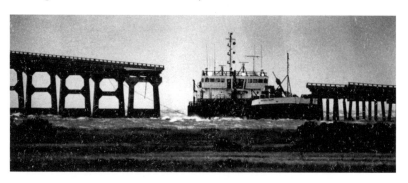

The dredge *Northerly Isle* drifted into the Herbert C. Bonner Bridge, causing a portion to collapse. *Drew C. Wilson Collection, Outer Banks History Center, 1990.*

October 27

1999—Crabber's Boat Hits Pound Net Pole and Sinks

While crabbing in the Croatan Sound, a Manns Harbor waterman ran over a broken pound net stake, which tore holes in the bottom of his thirty-foot boat. There was time to make a radio call to his brother, who was also fishing at the time. The vessel began to take on water quickly, and it was only a matter of time before the crabber and his mate were in the fifty-seven-degree sound. A dog onboard started swimming toward shore, three-quarters of a mile away, but was later retrieved. After receiving the call for assistance, the brother of the man in trouble radioed watermen who were nearby. The two men and dog were rescued by a Colington fisherman, but not before the damaged boat sank, taking with it over twenty boxes of crabs. With the help of friends, the boat was eventually patched enough to tow it to the dock, where it could be repaired.

October 28

1978—Landmark Hotel Burns in Early Morning Fire

A fire started on the third floor of the Nags Header Hotel on the oceanfront near Milepost 11. The blaze destroyed the wooden structure built in 1935. It was fortunate that firefighters responded quickly because windy conditions encouraged the flames. Nearby residents and businesses were on alert in case the fire spread, and members of the Nags Head Fire Department wetted down the tourist home Snug Harbor and Pictures Unlimited (today's Yellowhouse Gallery) across the Beach Road from the Nags Header. The hotel, which had not been in use, was one of the early hotels in Nags Head and hosted many a vacationer in its day.

October 29

1973—Jockey's Ridge Slated for State Park

The North Carolina Board of Conservation and Development recommended that Jockey's Ridge become a state park in order to keep private interests from developing it. The Nags Head sand dunes are the highest east of the Mississippi River. Citizens across the state worked in groups, such as the Friends of Jockey's Ridge and People to Preserve Jockey's Ridge, and mobilized to ensure that the dunes were kept in their natural state. Six months later, bulldozers cleared a large tract adjacent to the dunes so a group of town homes could be built. Jockey's Ridge became a state park in 1975.

October 30

1899—Schooner Stranded

The schooner *Roger Moore* was stranded east-southeast of the Big Kinnakeet Life-Saving Station during a rainy nor'easter. Crews from the Big Kinnakeet and Little Kinnakeet Stations responded. The wreck was so close to shore that a line was adhered without the use of a beach apparatus drill. Seven men from the *Roger Moore* made their way down the lines, assisted by surfmen who waded out to the vessel, which later became a total loss. The ship's crew was housed at the station for five days and given dry clothing from the stash provided by the Women's National Relief Association.

October 31

1972—Park Service Fish Fry Nets Over $2,000 for School

The Cape Hatteras School was awarded a check for $2,109.05, which represented the proceeds of a fish fry that took place at the Cape Hatteras Lighthouse during the summer. The event, held in commemoration of the National Park Service's centennial, was the brainchild of Preston Riddel, assistant superintendent of the Cape Hatteras National Seashore. In addition to raising money for Cape Hatteras School, the fish fry helped to foster good will between the National Park Service and the community. The check was presented at a meeting of the Cape Hatteras School PTA.

November 1

1993—Commissioners Vote No on Holiday Party

At a meeting of the Dare County Board of Commissioners, board members voted five to two against appropriating money for an employee Christmas party. While the member who introduced the resolution believed that a holiday gathering was an appropriate way to say thank-you at the close of the year, others did not. A nay-voting commissioner presented a compromise by suggesting that a planned party to thank county employees for their hard work following Hurricane Emily could double as a Christmas party. The Emily party would be funded by private donations. The use of public monies to fund holiday parties was also an issue discussed by Kill Devil Hills candidates for that town's board of commissioners.

November 2

2008—Could It Be a Manatee?

Local public opinion shifted after the Manteo dock master and other individuals confirmed that a creature sighted recently swimming about Shallowbag Bay near the downtown waterfront and the *Elizabeth II* historic site was not an alligator but rather a manatee. Videos and photos were later taken of the marine mammal, which bolstered the proof of its presence on Roanoke Island. After a storm, the creature disappeared, which was very good news for officials from the North Carolina Aquarium on Roanoke Island, who worried that the local climate was much too cold for manatees.

November 3

1889—Lifesaver Discovers Body on Hatteras

While performing regular duties patrolling the beach, a surfman from the Big Kinnakeet Life-Saving Station came across the body of a drowned man. Although fully clothed, there was nothing to determine the identity of the victim. The surfman returned to the station and gathered some lumber, nails and other crew members. After making a written description of the man and his clothing, the body was buried in a makeshift coffin.

November 4

1985—High Winds Halt Ferries as Tornadoes Touch Down

Two tornadoes touched down on Ocracoke Island within the span of an hour. Ferry service had been suspended because of high winds and over an inch of rain. The first tornado touched down at about 9:30 a.m., destroying a fish house, and the second struck about 10:30 a.m. The second twister damaged the roof of the ferry building, overturned boats and dented vehicles parked at the southern end of the island. The weather system that was working its way up from Florida and Georgia was not tropical but rather a typical winter weather system sometimes referred to as a Hatteras Low. Tornado warnings stayed in effect for a large portion of the day.

November 5

1982—Mainland Dare Link to Roanoke Island Severed

A vessel struck the William B. Umstead Bridge that connects Roanoke Island with Manns Harbor and mainland Dare County. Pilings were knocked out, concrete was cracked and, following inspection, the bridge was closed until repairs were made. Transportation to work for isolated employees who lived on the mainland was arranged on the *Crystal Dawn.* The head boat shuttled workers from Manns

A temporary ferry was enacted following the closing of the William B. Umstead Bridge. Daily Reflector *Negative Collection, J.Y. Joyner Library, East Carolina University, 1982.*

Harbor Marina to Pirate's Cove until a state ferry could be activated. A temporary school was set up at the Manns Harbor Community Building for mainland children unable to attend school in Manteo. The bridge was out of commission for eight weeks.

November 6

2001—Duck Residents Vote to Incorporate

By a two-to-three margin, residents of the north beach village of Duck voted to incorporate and become Dare County's fifth municipality. Of 410 registered voters, 171 cast their ballots in favor of incorporation, with 113 casting ballots against becoming a town. The victory came after two and a half years of lobbying. Those favoring incorporation cited maintaining Duck's unique charm and village atmosphere as a chief goal of becoming a town. An appointed town council would govern until an official election could be held the following November. Duck officially became a municipality on May 1, 2002.

November 7

1973—Hatteras Man Lands Record Drum

During a late night/early morning fishing session on Rodanthe's Hatteras Island Pier, Elvin Hooper caught a ninety-pound red drum, also known locally as channel bass. The fish, which was caught on twenty-five-pound test fishing line, took an hour to land and became a new world record, breaking the old record, set in 1949, by six pounds. The new record fish measured fifty-five and one-quarter inches from tip to tail and had a thirty-eight-inch girth. Coincidentally, ten years later, on November 7, 1983, Dave Deuel, fishing on the

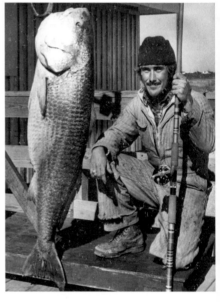

Elvin Hooper poses with his world-record red drum. *Aycock Brown Collection, Outer Banks History Center, 1973.*

beach at Avon, broke Hooper's record when he landed a ninety-four-pound fish.

November 8

1962—D'Oh! A Deer!

Wildlife authorities picked up a deer the day after it inflicted terror on an elderly Kitty Hawk woman. The seventy-two-year-old was in her backyard when the animal knocked her down. She was able to escape to her garage, but the deer followed and pushed the Kitty Hawker into a wheelbarrow. The woman screamed for help and was aided by a neighbor, who hurled a gallon jug of water at the aggressive creature. The woman, shaken by the encounter, was taken to Albemarle Hospital in Elizabeth City, where she was treated for a fractured wrist and injuries to her knee.

November 9

1942—Men Charged with Responsibility of Retrieving Wright Flyer

At a supper meeting of the Manteo Rotary Club, a committee was established for the purpose of bringing the Wright Flyer, the vessel in which Orville and Wilbur Wright made history when they sailed over the sands near Kill Devil Hills in 1903, back to the Outer Banks. The antique aircraft was in England. The men charged with the task were William Tate, John T. Daniels, D. Victor Meekins, D. Bradford Fearing and Horace Dough. Tate and Daniels had known Orville Wright for forty years. Meekins published the local paper, Fearing was involved with *The Lost Colony* and Dough was caretaker of the Wright Memorial.

November 10

1990—Twister Hits Isolated Hatteras Island

To heap misery on top of an already bad situation, a tornado touched down on Hatteras Island. It happened less than one month after the island's direct link to the northern Outer Banks was severed when a barge slammed into the Herbert C. Bonner Bridge, taking out a portion of the span over Oregon Inlet. The tornado was part of a weather system that moved through the area with heavy rains and winds over seventy-five miles per hour. The twister hopscotched a ten-mile path between Avon and Frisco. Although no serious injuries were reported, two people required stitches from injuries sustained when the storm touched down. Property damage included downed trees and power lines, missing shingles and dings to vehicles.

November 11

1954—Wild Geese That Fly with the Sun on Their Wing

Early morning ferry passengers crossing Oregon Inlet bound for Hatteras on the *Conrad Wirth* were treated to a remarkable sight. Hundreds of greater snow geese were flying in perfect V-formations silhouetted against a bright orange morning sky. The waterfowl were part of an off-season population of 4,500 geese that wintered at the Pea Island National Wildlife Refuge.

November 12

1986—Canis Rufus *Arrive via Airplane*

Eight red wolves arrived at the Dare County airport from federal breeding centers in Missouri and Washington states. The species was declared extinct in the wild in the 1970s, and it was hoped that the four pairs would be released in the nearby 120,000-acre Alligator River National Wildlife Refuge on the Dare County mainland and that wolves would again roam free in their natural habitat. Similar programs introduced in other areas of the country had failed because of lack of public support. The sparsely settled peninsula between the Albemarle Sound and the Pamlico River was thought to be a suitable habitat and a good match for the wolves.

November 13

1937—Greek Sailors Endure Maritime Catastrophe

The Coast Guard cutter *Mendota* rescued fourteen Greek sailors from a shark-infested sea after their vessel, the Greek freighter *Tzenny Chandris*, loaded with a cargo of scrap metal, sank off Cape Hatteras in foul weather and high seas. Crewmen, fearful of their fate, had pleaded with the captain to send an SOS signal to one of the ships the *Tzenny Chandris* passed on its route toward Rotterdam, Germany. But the captain believed that the pumps would keep the freighter operable. One sailor's testimony, which was later retracted, said that he threatened a fellow crew member with a knife if he did not send a distress message. After the ship went down, livestock that had been on board became prime pickings for sharks, as did the men in the water. In all, twenty were saved and nine perished in the frightful ordeal on the high seas.

November 14

1970—Local and Visiting Anglers Enjoy Epic Fishing

A week of spectacular fishing began along the Outer Banks that was described as the "best surf fishing in recent years" and perhaps the "best week ever." The word spread quickly up and down the beaches, and many anglers got in on the action. Timing was perfect for a group of out-of-town sportswriters who happened to be in the area at the same time as big blues, stripers and trout. Karl Osborne, a sportswriter from Vero Beach, Florida, along with seven other anglers, started things off when they caught over seventy-five bluefish at Duck that weighed between fifteen and twenty-one pounds.

November 15

1999—Workers Plucked from Icy Sound

After a wave capsized the pontoon barge on which they were working, seven men were dumped into the wintry water of the Currituck Sound. Although they experienced hypothermia, the men who were working on the utility lines north of the Wright Memorial Bridge all wore life preservers and were rescued. The barge was on its way back to shore when it was overturned. Winds were estimated at between twenty-five to thirty knots. One of the workers was able to call 911 on his cellphone. The rescue was a joint effort by the Currituck County EMS, the North Carolina Department of Transportation and the Coast Guard.

November 16

1972—Publicity Man Honored

In conjunction with the twentieth anniversary of the founding of the Dare County Tourist Bureau, the Dare County Board of Commissioners proclaimed the day "Aycock Brown Day" in honor of the bureau's first news director. Brown, an indefatigable promoter of the Dare Coast beaches and the Sir Walter Raleigh coastland, established a special knack for getting Outer Banks photos and articles in newspapers across the nation. The Tourist Bureau's twentieth-anniversary banquet, held in the Quarterdeck Lounge at the Seafare Restaurant in Nags Head, began with a social hour followed by dinner. The guest book read like an area who's who.

November 17

1982—Governor Tends to Dare Business

North Carolina governor Jim Hunt took advantage of a quick trip to Dare County to take care of a number of ceremonial duties. He nailed a plaque made of copper from the dome of the state capitol building in Raleigh on the *Elizabeth II*, the sixteenth-century representative sailing ship that was under construction in Manteo. Over at the Dare County Courthouse, Hunt dedicated two plaques. One honored the service of Chauncey S. Meekins, who served as clerk of court for fifty-six years, and the other honored the service of Frank M. Cahoon, who served as sheriff for thirty-six years. The governor also inspected the William B. Umstead Bridge, which had recently sustained damage when struck by a vessel.

November 18

1959—Tug Aflame at Manteo

Max Mann, crewman on the sixty-five-foot tugboat *Fisher*, left a Manteo billiard establishment, smelled smoke and thought something was amiss. He discovered the *Fisher* on fire and attempted to extinguish the flames himself. After determining the task was too great, he alerted the local fire department, which quelled the blaze at the Manteo town dock. The tug, owned by the M.L. Daniels Oil Company, suffered approximately $4,000 in damage and was taken to Norfolk for repairs. The fire began in the ship's galley and was mysterious because no one was aboard at the time Mann discovered the *Fisher* aflame.

November 19

2006—Dog Leaps from Vehicle, Begins Four-Year Mainland Odyssey

Teddy Bear, a medium-sized, mixed-breed dog from New Bern, North Carolina, jumped from the back of her family's hatchback during a visit to the Alligator River Wildlife Refuge on mainland Dare County. She disappeared. Her frantic owners searched from mid-day until eight o'clock at night for their beloved pet. They printed flyers about the missing dog, placed ads in the *Coastland Times* and worried about exposure, wild animals and rough conditions that existed on the refuge. But Teddy Bear, who was very skittish, was fed scraps by some men living near the refuge, and over time, one lured her close enough that she entered the house and was then taken to the Dare County SPCA. Her file was pulled, her parents were contacted and she was reunited with her family. During the four-year stay on the refuge, Teddy Bear lost fifteen pounds.

November 20

1963—Ferry Era Ends at Oregon Inlet

Ferries at Oregon Inlet made their final trips across that fickle waterway as the Herbert C. Bonner Bridge, which connected Bodie and Hatteras Islands, opened to traffic. While a ribbon was cut to mark the span's debut, the formal dedication of the bridge took place in the spring of the following year. Prior to opening to the public, the important link between Hatteras Island and the northern Dare beaches was used in emergencies such as hurricane evacuation and to transport critical medical cases that before had to rely on boat or air transportation.

November 21

1971—Stumpy Point Native and Authoress Honored

The Manteo Library partnered with several area women's clubs to put together a party and book-signing event for Nell Wise Wechter, a teacher and author of local history books for young adults. Among Wechter's works were *Taffy of Torpedo Junction*, winner of the American Association of University Women Award for Juvenile Literature; *Swamp Girl*; and *Betsy Dowdy's Ride*. The event, held in the library's Georgia Harwood Room, was sponsored by the Manteo Women's Club, the Outer Banks Women's Club and the Dare Homemakers' Club.

November 22

1718—Notorious Pirate Slain

During a fierce hand-to-hand battle off Ocracoke Island, Lieutenant Robert Maynard killed Edward Teach, alias Blackbeard. Teach endured five pistol shots and twenty sword cuts and slashes during the fight. His head was then severed from his body and hung on the bowsprit of the sloop as proof that the bold Blackbeard had been defeated. His body was tossed overboard. Storytellers and raconteurs embellish that the headless corpse swam around the ship seven times. Maynard, of the British Royal Navy, had sailed at the request of Governor Spotswood of Virginia, who had been petitioned by planters from North Carolina to do something about Blackbeard's stronghold on Carolina waters.

Lieutenant Robert Maynard battles with notorious pirate Blackbeard near Ocracoke. *State Archives of North Carolina.*

November 23

1956—Griffiths Spend Holiday Time at Island Home

Andy Griffith and his wife, Barbara Edwards Griffith, were on Roanoke Island spending some time prior to the filming of the feature film *No Time for Sergeants*, in which Griffith was to play the lead. They were accompanied by New Yorker Paul Silbert, who acted as art director in Griffith's first film, *A Face in the Crowd*. Silbert, who was purportedly an expert with a bow and arrow, hoped to do some hunting during his stay and sought large game on the Dare County mainland. The Griffiths, former cast members of *The Lost Colony* drama performed each summer on Roanoke Island, arrived for their stay early on Thanksgiving Day.

November 24

1952—Application for Pier on Hatteras Island Announced

A notice from the U.S. Army Corps of Engineers district office in Wilmington, North Carolina, publicized plans for construction of a pier at Rodanthe. The proposed structure would be twelve feet wide and six hundred feet long. The man behind the effort was Nags Head's R.D. Owens, who submitted the application. The notice also said the Corps of Engineers would accept written letters from those with any opposition to the pier project. While the filing of the application coincided with the establishment of the Cape Hatteras National Seashore and the completion of Highway 12, a pier was not built at Rodanthe until 1960.

November 25

1875—Curritucker Performs Heroic Rescue

Currituck native Malachi Corbell rescued two black fishermen, Willis Wescott and James Gray, off the bar near Caffey's Inlet after their small boat overturned. Corbell, whose boat also capsized during the rescue attempt, was able to bring the exhausted men to shore, but not before two of its crew perished. For his actions, Corbell was awarded a silver Congressional Life-Saving Medal two years later. He was one of the first North Carolinians to receive this special award. Corbell would later serve as keeper of the Caffey's Inlet and Wash Woods Life-Saving Stations. He died in 1908 and was buried in the Knotts Island Cemetery.

November 26

1977—Funds Obtained to Preserve Wetlands

The Nature Conservancy unveiled plans to use a $4 million grant from the Richard King Mellon Foundation to protect Monkey Island and Swan Island in the Currituck Sound. The land, which was to remain in its natural state, encompassed over six thousand acres of brackish marshes and small islands. The parcels were important habitats for an estimated 170,000 waterfowl that migrated through the Atlantic Flyway, including mallards, widgeons, canvasback and snow and Canada geese. Over 100 bird species had been recorded in the area. The grant was the largest of its kind to a private conservation organization.

November 27

1928—Kitty Hawker Writes Wright

William Tate, friend of the Wright brothers, wrote a letter to Orville Wright in anticipation of the pioneer aviator's return to the area to commemorate the twenty-fifth anniversary of the first flight. He predicted that Wright's arm would be sore when the hand shaking was over. Tate, who hosted the Wright brothers early in their experiments at Kitty Hawk, was keeper at the Coinjock Depot along the Albemarle and Chesapeake Canal and invited Wright to ride to the festivities in his "good closed car." The two remained friends for many years.

November 28

1945—Norfolkians Drive to Manteo,
Get Drunk, Fight and Steal Auto

A man and woman from Norfolk, Virginia, created a stir after they drove to Roanoke Island, "freely imbibing" along the way. Their intoxicated state caused the man to hit the woman, and then he stole the automobile of Alpheus W. Drinkwater. It was reported that Drinkwater expressed trepidation about driving his '35 Plymouth because he feared a tire would blow out. The Norfolk drinker/car thief took the vehicle from in front of Drinkwater's home and, for a stretch up the Beach Road, made good speed until the engine threw a rod near the entrance to the Wright Memorial Bridge. Kitty Hawk deputies Perry and Belangia apprehended the suspect, who was trying to hitch a ride when they picked him up. The woman was picked up in Manteo. Both were charged with drunk driving, and he was charged with auto theft.

November 29

1967—Suspected Bomb Snagged Near Oregon Inlet

While crabbing in seven feet of water in Old House Channel west of the Oregon Inlet Bridge, the trawler *Nellie E.* snagged what was thought to be a five-hundred-pound bomb. As the vessel had no radio, the captain relayed a message to the Coast Guard via the trawler *Edna Kay*. After the captain and two-woman crew aboard the *Nellie E.* were taken off the fishing boat, a navy demolition team was brought in to dislodge the explosive, but the operation was suspended as darkness fell. The following day, the seven-man demolition squad recovered the eighteen-inch object, which turned out to be a piece of dredging pipe.

November 30

2006—Pass the Salsa

A shipping container full of four hundred boxes, each containing twenty bags of Doritos tortilla chips, washed ashore in Frisco near the Cape Hatteras Fishing Pier and was broken into by enterprising charter boat captains. As word spread along the island, residents arrived at the site and cleaned the beach while picking up some spare munchies in return. The container was one of four that had washed off the freighter *Courtney L* a week prior. The whereabouts of the other three containers was unknown as the Doritos came ashore on Hatteras. One container was full of Frito-Lay snack products, and the other two carried paper products.

December 1

1875—The Dark Space Is Filled

The stately red brick Currituck Beach Lighthouse was illuminated for the first time under the watch of keeper N.H. Burris. It was the last of the seacoast lights built north of Cape Lookout on the North Carolina coast. Its initial flash pattern was a steady white light with a five-second intermittent red flash every eighty-five seconds. The 158-foot spire filled a void along the coast between the Cape Henry Lighthouse at the entrance to the Chesapeake Bay and the Bodie Island Lighthouse near Oregon Inlet. The current flash pattern, visible for nineteen miles out to sea, is a white signal three seconds on, seventeen seconds off.

December 2

1969—Griffith Named as Award Winner

At a meeting of the Roanoke Island Historical Association, producer of *The Lost Colony* outdoor drama, newspaperman Sam Ragan of Southern Pines, North Carolina, announced that television and movie celebrity Andy Griffith would be awarded the third-annual Morrison Award. The award was established locally in honor of Dr. and Mrs. Fred W. Morrison, who were staunch supporters of the drama. The award is given to a North Carolinian in the performing arts who has brought recognition to his or her native state. Before starring in his own television show, Griffith played the part of Sir Walter Raleigh in *The Lost Colony.*

December 3

2004—Manteo Students Receive Computers

Television personality and part-time Roanoke Island resident Andy Griffith made an announcement at Manteo's "Christmas through Four Centuries" holiday celebration about an opportunity to bring computers and high-speed Internet to children. Griffith shared the news that, in a partnership that included the town of Manteo, Charter Communications, IBM and VitalSource, school-aged children living within town limits would receive computers, educational software and free high-speed Internet access. Sharing the stage with Griffith was Manteo mayor John F. Wilson IV, who cited the need for computers and Internet access for students to reach their educational potential. It was the first time an American municipality offered free wireless service to its students.

December 4

1994—Whale Freed After Three-Hour Rescue

A thirty-two-foot humpback whale was freed after being entangled in a one-hundred-foot gill net. Seven emergency rescue workers from Chicamacomico and Hatteras (including two off-duty coastguardsmen) worked from the water to untangle the sea mammal, which was entrapped in the net three hundred feet off shore south of Oregon Inlet. An additional team of five supported the rescue from shore. When last seen, the whale appeared to be in good health as it headed out to sea. During the rescue, another whale was spotted, giving rescuers hope that the snared whale had not been abandoned by others.

December 5

1941—Outdoor Writer Spends Time at Currituck Beach

New York Times columnist Raymond R. Camp wrote several articles for his column "Wood, Field and Stream" while on a duck hunting trip to the Whalehead Club in Corolla. Camp, who along with his hunting party managed to shoot two shovelers, two redheads and a ruddy duck, made note of the poor hunting conditions, citing lack of rain and lack of wind as hindering the congregation of waterfowl. The wind never exceeded ten miles an hour, and he and his companions were ready to call it quits by the 4:00 p.m. curfew. Camp met a man who had worked hard to visit Currituck in prime duck hunting season. In eight days, the hunter had killed just eleven ducks.

December 6

1911—Station Keepers Awarded Medals

E.H. Peel, keeper of the Creeds Hill Life-Saving Station, and B.B. Miller, acting keeper of the Cape Hatteras Life-Saving Station, were awarded the Gold Lifesaving Medal for orchestrating the November 1909 rescue of men off the stranded German steamer *Brewster*. The rescue was made in two boats launched from the beach, one powered by motor and one powered by oars. Twenty-eight men were taken to shore by the lifesavers; five others boarded a boat and were picked up by the Cape Hatteras Lightship. Keepers Peel and Miller and the station crews were recognized for the rescue by the German government.

December 7

1895—President Does Well with Ducks

After a day of shooting near Bodie Island Lighthouse, President Grover Cleveland and his hunting party bagged seventeen ducks and two swans. The following day, the chief executive, traveling on the lighthouse tender *Violet*, encountered bad weather and anchored off the Roanoke Marshes Light, but the president and his party were never in any type of danger. The *Violet* would later make a stop at Elizabeth City, where the president was fêted by the fine people of that riverfront town before he left on a special train for Norfolk, where he boarded the lighthouse tender *Maple* for his trip back to Washington, D.C.

December 8

1984—Trawler Righted After Ten Days

On a calm late autumn day, the fishing trawler *Theodore Maria*, which had been aground near Ocracoke Inlet for over a week, was floated free by the LePage Salvage Company out of Wanchese. Eight pumps were used to clear the water out of the eighty-foot wooden fishing boat, which was loaded with trout and flounder when it grounded. The smell of the fish was an obstacle to overcome during the operations, plus at times the fish would get stuck in the pumps. Art LePage, owner of the salvage company, admitted that although he had a strong stomach, when he got near the fish hold, he "was almost over the side." In preparation for the floating, the *Theodore Maria*'s fuel had been removed days earlier to lighten the vessel.

December 9

1976—Park Service Leaders Meet with Island Residents

The superintendents from the Cape Hatteras and Cape Lookout National Seashores met with residents of Ocracoke Island to "share our mutual concerns and thoughts and to exchange information about Cape Lookout and Cape Hatteras Seashores." The gathering was held at the Ocracoke Fire Station, and it was hoped that this and a series of other get-togethers dubbed "unity meetings" would work to forge a relationship between citizens and the National Park Service. It was the second meeting of this type. A similar one was held on Hatteras Island the month before.

December 10

1968—Hearing on Red Drum Limits Draws Crowd

One hundred people, more or less, attended a hearing at the Dare County Courthouse on whether or not to maintain the current restriction on red drum catches. Regulations limited drum to two a day over thirty-two inches. Recreational fishermen and representatives from the tourism industry were in favor of protecting the species and keeping the limits, while commercial fishermen, who occasionally netted drum while fishing for other species, wanted to be able to sell their catch legally. A number of individuals, representing both sides of the issue, spoke at the meeting. A member of the advisory committee was pleased that so many citizens cared enough to attend the hearing and to have their views heard. He said that turnout had been low at a similar meeting in New Hanover County. Restrictions on drum in 2013 allow for one fish per day between eighteen and twenty-seven inches.

December 11

1954—Officials Review Coquina Beach Architectural Plans

Architects from the Eastern Office of Plans and Design in Philadelphia were at National Park Service headquarters on Roanoke Island presenting scale models of five different plans for buildings at the Coquina Beach day-use area of the Cape Hatteras National Seashore. While the design of the buildings ranged from "conventional to the ultra-modern," they all were planned to be of use to visitors to the park. Bathrooms, showers, a changing area, an information center and picnic tables with sunshades were in the works for the beach access area across from the Bodie Island Lighthouse. The plans were under review and evaluation.

December 12

1982—Trawler Runs Aground and Sinks at Inlet

The eighty-nine-foot trawler *Lois Joyce*, captained by fisherman Walter Tate, ran aground at Oregon Inlet. The experienced waterman kept the propellers running in order to dig a hole under the boat to keep it from overturning. Two coastguardsmen wearing survival suits approached the *Lois Joyce* in a rubber rescue raft to adhere a towline, but the raft overturned.

The trawler *Lois Joyce* in Oregon Inlet, shortly after its crew was evacuated via Coast Guard airlift. *Photo by and courtesy Eve Trow Turek, Yellowhouse Gallery, Nags Head, NC, 1982.*

They were rescued about an hour later. Six crewmen from the *Lois Joyce* were airlifted to safety. The trawler later sank carrying three thousand pounds of flounder and was quickly enveloped by the inlet's shifting sands.

December 13

1885—Lost Woman Sheltered at Life-Saving Station

While on patrol between sunset and 9:00 p.m. on a wintry rainy evening, a surfman from the Currituck Inlet Life-Saving Station found a woman from Kitty Hawk who had lost her way. She appeared disoriented and was taken to the station, where she was given some food. The traveling woman was given succor and shelter for the night before continuing on her way the following morning.

December 14

1959—Citizens Want Another Bank

Ben Roberts, North Carolina commissioner of banks, attended a meeting at the Dare County Courthouse. The gathering, the first of its kind in Dare, allowed local citizens to express their desire for more banking options in the county and to petition for authority to establish the People's Bank of Dare. Over 150 citizens attended from all parts of the county, including its far-flung regions. In opposition to the plan was the Bank of Manteo, which had been operating in town for over fifty years and wanted to continue as the lone bank in Dare County. Proponents of the new bank (many prominent businessmen from Roanoke Island, Hatteras and the northern beaches) claimed that with recent growth in the county, the area would be able to support two banks. The banking commission denied the request the following month.

December 15

1883—Beacon Light Shines After Repairs

The light on the Cape Hatteras Beacon was re-exhibited after repairs were made to the small, square, stout wooden structure. The building had been all but abandoned since it stopped shining in 1879. Ten years after the relighting, a publication of the United States Lighthouse Board described the beacon light as having a sixth-order Fresnel lens with a fixed white light. At a height of twenty-seven feet, its signal could be seen for ten and a half miles out to sea. During its forty-three-year lifespan, the beacon was moved several times.

December 16

1986—Yeager Seeks Speed Record

Celebrated aviator Chuck Yeager, who broke the sound barrier in 1947, took off from Edwards Air Force Base in California at 10:40 PST en route to Kill Devil Hills. Yeager's goal was to create a speed record for the 2,300-mile flight between two important aviation points—Edwards AFB and the landing strip adjacent to the Wright Brothers Memorial. The record was set on the eighty-third anniversary of the Wrights' first flight. The historic undertaking, made in a Piper Cheyenne 400LS, took five hours and fifteen minutes. When asked about his experience, the playful Yeager admitted, "It'll never replace sex."

December 17

1903—Flight Achieved Near Kitty Hawk

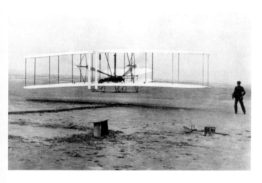

Wilbur Wright runs alongside the Flyer as Orville Wright makes the famous first flight. *State Archives of North Carolina, 1903.*

The age of aviation was ushered in at 10:35 a.m. on a windy day when Orville Wright made the first free flight in a heavier-than-air craft near the big sand dune at Kill Devil Hills. The Ohioan stayed aloft for twelve seconds and flew 120 feet, while his brother Wilbur looked on. John T. Daniels, stationed at the Kill Devil Hills Life-Saving Station, was enlisted to man the Wrights' box camera and was instructed to squeeze the bulb when the flyer lifted off the ground. Daniels followed instructions and, in so doing, took one of the most recognizable photos in the world. Three additional flights were made that morning. In the afternoon, the brothers visited the Kitty Hawk Weather Station and sent a telegram to their father in Dayton, Ohio, announcing their success and their plans to be home by Christmas.

December 18

1928—Last Ferry Transports Guests

At 1:30 a.m., the final group of revelers who attended the twenty-fifth-anniversary celebration of the Wright brothers' first flight at Kill Devil Hills arrived at Point Harbor after a ferry trip across the Currituck Sound. The crowd at the event, which included dignitaries, aviation enthusiasts, politicians and Orville Wright, was estimated at two thousand attendees. Following the ceremonies, the line of automobiles waiting for ferry service at times stretched two miles through Kitty Hawk. On an earlier ferry trip, Allen R. Hueth had died suddenly. Hueth, from Ashbury, New Jersey, was one of the donors of the five-hundred-acre tract on which the Wright Memorial was to be built.

December 19

1977—Barge Founders Off Hatteras

While being towed in heavy seas and seventy-mile-per-hour winds, the barge *Poseidon* broke loose from the tug *Texan* forty miles off Cape Hatteras. The 414-foot vessel, carrying over six thousand tons of the industrial solvent carbon tetrachloride, was adrift in the Atlantic Ocean. Nine crewmen from the *Texan* were rescued by a Coast Guard helicopter after they boarded the *Poseidon*, believing the barge was safer than their tug. The men were airlifted from the barge and taken to Elizabeth City. The Coast Guard was unable to affix a line to the ship because of the hurricane-like conditions.

December 20

1968—Ocracoke Gets Modern Airstrip

One hundred people took part in the dedication of a new paved airstrip on Ocracoke Island. Norfolk industrialist and Ocracoke property owner Sam Jones was instrumental in the construction of the airstrip and was the first to land on the three-thousand-foot runway in his airplane, Ocracoke Carosel. A state-owned DC-10, the Carolina Cardinal, brought North Carolina officials to take part in the ceremony on the isolated island. Citizens had been lobbying for a paved airstrip for ten years before state funds were officially allocated for the project. Before the airstrip was built, pilots landed their aircraft directly on the highway.

December 21

1942—Pilots Perish in Unforgiving Sea

While on patrol on a windy and bitterly cold evening, civilian pilots Frank M. Cook from Concord, North Carolina, and Julian L. Cooper from Nashville, North Carolina, flying out of Civil Air Patrol Coastal Air Patrol Base 16 on Roanoke Island, abandoned their faltering aircraft and perished in the Atlantic Ocean. Coastguardsmen from Nags Head, Oregon Inlet, Pea Island and Chicamacomico Stations made every attempt to launch their lifeboats to rescue the aviators, but the pounding surf prevented it. A memorial to the pilots and to others stationed at CAP Base 16 was unveiled at the Dare County Airport in April 1997.

December 22

1971—Three Lost as Trawler Breaks Up at Inlet

While attempting to enter Oregon Inlet in the predawn darkness, a distress call was issued by a crewman aboard the trawler *Lane*. He reported that the vessel was being driven ashore by thirty-knot winds. The old wooden craft broke up quickly, and its wreckage drifted over a large area. Three black commercial fishermen who were aboard the fifty-eight-foot shrimper perished. Two of the bodies were retrieved by a Coast Guard helicopter after the sun rose, but the other was never recovered. The men were from the Pamlico County, North Carolina communities of Merritt and Bayboro.

December 23

2004—Sea Foam Motel Recognized on Historic Inventory

Nags Head's Sea Foam Motel, host of vacationers to the Outer Banks for over fifty years, was added to the National Register of Historic Places. Roanoke Island's Theodore and Rosa Midgett Meekins began buying oceanfront lots in 1946 and 1947 and, the following year, built a small, single-story brick hotel perpendicular to the ocean during the building boom that followed World War II. A second-story addition was built in 1951, and another portion to complete the U-shape on the current motel was built in following years. The Sea Foam was recognized for its typical roadside motel architecture and features, such as the in-ground pool, knotty pine interior and sea foam–green gables set off against the white railing and brick exterior. Today, the Sea Foam continues to welcome visitors ready and willing to rejuvenate in the nostalgic and seaside atmosphere it provides.

December 24

1899—Twenty-One Dead After Lifeboats Capsize

The British steamer *Ariosto*, with thirty men aboard, ran aground off Ocracoke Island on a morning when conditions were described as "thick." The ship's captain was unable to discern his location and believed the vessel was stuck on Diamond Shoals off Cape Hatteras. For this reason, he gave orders to abandon ship. Twenty-four members of the crew boarded two of the vessel's lifeboats to await rescue, but the boats were swamped. Three lucky men were plucked from the surf, but twenty-one men perished. Some of their bodies were collected later along the shore. The six men who remained on board were rescued by use of the breeches buoy. The surfmen believed that had the crew stayed with the *Ariosto*, none would have died at the scene.

December 25

1932—Manteo Burns in Holiday Blaze

A fire in Manteo destroyed six downtown businesses, including a confectionary, pool hall, barbershop and drugstore. The courthouse and county jail suffered damage from the intense heat of the conflagration, which also caused the metal tower of the U.S. Weather Bureau to twist and then fall on the town's charred remains. Bucket brigades formed as citizens and coastguardsmen from local stations battled the flames. They were later assisted by a detachment from the Elizabeth City Fire Department. The hero of the day was Bitsey, a cream-colored, mixed-breed dog belonging to the Wescott family. Bitsey's barking alerted her owners and five others living above the Wescott Confectionary of the fire. She survived but suffered burns while making her escape. Bitsey was taken to the Burnside Road home of G.T. Wescott to convalesce. The blaze, estimated as causing $35,000 in damage, drew attention to the need for fire protection in Manteo.

December 26

1903—Tate Vows to Keep Mum to Press

Kitty Hawk's William Tate, friend, host and confidant of the Wright brothers, penned a letter to Wilbur Wright explaining that he was in Elizabeth City on December 17, the day "you made your experiment with your flying machine." Tate informed Wright about articles that were written in Norfolk's *Virginian Pilot* and Elizabeth City's *Daily Economist* covering the experiments. The *New York Journal* and *Norfolk Dispatch* had contacted Tate, offering to pay him for a six-hundred-word and a five-hundred-word article, respectively. A loyal friend, the Kitty Hawker was aware of the Wrights' request that "nothing should be given out for publication." He informed reporters that experiments were carried out discreetly, and no information was available.

December 27

1980—Trawler Damaged on Maiden Voyage

Caught in waves estimated at twenty feet, the brand-new trawler *Miss Quality*, owned by Elizabeth City's Quality Seafood Company, sustained damage during its sea trials. In the early morning darkness, a large wave shattered the pilothouse windows and knocked out *Miss Quality*'s radio and other navigation aids. Captain Rex Etheridge was unable to report his position at a predetermined specified time and was then reported overdue to the Coast Guard. A Coast Guard aircraft located the *Miss Quality* and dropped a radio to the damaged ship. Captain Etheridge described the event as "frightening" and thanked the members of the Coast Guard, who were always willing to come to the aid of distressed mariners.

December 28

1885—Island Native Appointed to Serve at Croatan Light

John Shannon of Roanoke Island was appointed to the position of assistant keeper at the Croatan Light Station at the northwest entrance to the Croatan Sound. His annual salary was $420 per year. Shannon served a year and a half at the isolated screwpile lighthouse off Roanoke Island's north end until he was transferred to the Bodie Island Lighthouse, where he also served as assistant keeper. He remained at Bodie Island for ten years and then started a family. John Shannon's descendants reside on Roanoke Island today.

December 29

1981—Causeway Scene of Parking Lot Scuffle

A Kill Devil Hills teenager was fined in district court after she was found guilty of assault and battery for what was described as a hair-pulling incident. The ruckus took place outside the Drafty Tavern on the Nags Head–Roanoke Island Causeway, an establishment that, although fondly remembered, had the reputation for being on the rough side. The teen reportedly became loud and boisterous inside the Drafty Tavern and followed another patron into the parking lot, where she poured beer on the woman. An exchange of heated words was followed by slapping and hair pulling. The woman lost a large patch of hair, while the teen reported no injuries.

December 30

1964—First Greylag Goose Sighting

William C. Goode, refuge manager at the Pea Island National Wildlife Refuge on Hatteras Island, espied a pair of eastern Greylag geese, interspersed with snow and Canada geese, that were feeding on the refuge. It was the first sighting of eastern Graylags on the refuge and possibly on the East Coast. The geese were normally found in Europe and Asia. Other notable sightings for the 1964 season were a sand hills crane on May 14 and a flamingo on December 14. Recreational users to the Pea Island Refuge during the year came from thirty-nine states and eight foreign countries.

December 31

1862—Ironclad Monitor Sinks in Morning Hours

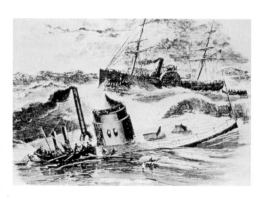

The USS *Monitor* foundering in high seas off Cape Hatteras, December 31, 1862. *OAR/National Undersea Research Program National Oceanic and Atmospheric Administration/Department of Commerce.*

While being towed by the USS *Rhode Island*, the USS *Monitor*, the ship that dueled to a draw with the Confederate ironclad *Merrimac* in Hampton Roads Harbor, sank in high seas off Cape Hatteras. It was on its way to Beaufort, North Carolina, for repairs and then on to Charleston, South Carolina. Spirits were high the evening prior, when the *Monitor* rounded Cape Hatteras, the first ironclad to do so. But soon afterward, a towline snapped, and the *Monitor* was on a course for disaster. Forty-seven men were rescued from the ironclad before it went down, but sixteen men perished with the vessel. During excavation of the *Monitor*'s revolving turret in 2002, bones of two sailors were discovered. They were buried with full military honors at Arlington National Cemetery in 2013.

SELECTED BIBLIOGRAPHY

Byrd, William, and William Kenneth Boyd. *William Byrd's Histories of the Dividing Line Betwixt Virginia and North Carolina.* Raleigh: North Carolina Historical Commission, 1929.

Carter, Kathleen S. *The More Things Change: Oysters, Public Policy, and Species Decline in the Pamlico Sound, 1880–1900.* IIFET 2000 Proceedings.

Lee, David S. "Long Legged Pink Things: What Are? Where Do They Come From?" *Chat* (Spring 1987): 43.

Powell, William Stevens. *Paradise Preserved.* Chapel Hill: University of North Carolina Press, 1965.

Quinn, David B. *Set Fair for Roanoke: Voyages and Colonies, 1584–1606.* Chapel Hill: Published for America's Four-Hundredth Anniversary Committee by the University of North Carolina Press, 1985.

Renstrom, Arthur George. *Wilbur & Orville Wright: A Reissue of a Chronology Commemorating the Hundredth Anniversary of the Birth of Orville Wright, August 19, 1871.* Washington,

D.C.: National Aeronautics and Space Administration, Office of External Relations, NASA History Office, NASA Headquarters, 2003.

Shelton-Roberts, Cheryl, and Bruce Roberts. *North Carolina Lighthouses*. Morehead City, NC: Lighthouse Publications, 2000.

United States. *Annual Reports of the Light-House Board to the Secretary of the Treasury, 1852–1903*. Washington, D.C.: Government Printing Office.

————. *Annual Reports of the United States Life-Saving Service, 1876–1914*. Washington, D.C.: Government Printing Office.

————. *Official Records of the Union and Confederate Navies in the War of the Rebellion*. Washington, D.C.: Government Printing Office, 1894.

United States Fish and Wildlife Service. "Pea Island National Wildlife Narrative Report." January 1– December 31, 1964.

United States, Robert N. Scott, H.M. Lazelle, George B. Davis, Leslie J. Perry, Joseph W. Kirkley, Fred C. Ainsworth, John S. Moodey and Calvin D. Cowles. *The War of the Rebellion: A Compilation of the Official Records of the Union and Confederate Armies*. Washington, D.C.: Government Printing Office, 1880.

Newspapers

Bee (Danville, VA)

Burlington (NC) Daily News

Chicago Tribune

Coastland Times (Manteo, NC)

Daily Advance (Elizabeth City, NC)

Dare County Times (Manteo, NC)

Edenton (NC) Gazette

Freelance Star (Fredericksburg, VA)

Independent (Elizabeth City, NC)

News and Observer (Raleigh, NC)

New York Times

Outer Banks Sentinel (Nags Head, NC)

Robesonian (Lumberton, NC)

Rocky Mount (NC) Evening Telegraph

Star News (Wilmington, NC)

Statesville (NC) Landmark

Times News (Hendersonville, NC)

Virginian-Pilot (Norfolk, VA)

ABOUT THE AUTHOR

Sarah Downing has made her home on North Carolina's Outer Banks for thirty years. She was drawn to the natural beauty and open spaces that the land and sea provided, but she quickly became immersed in the history and lore of her adopted home as well. Since 1991, Sarah has been associated with the Outer Banks History Center in Manteo, where she currently serves as assistant curator. A certified North Carolina librarian, Sarah

Photo by Becky "Shells" Ballou.

enjoys writing, cooking, beachcombing, surfing and taking walks in the many natural areas of the Outer Banks. She lives in Nags Head with her husband and a mixed-breed dog. *On This Day in Outer Banks History* is the author's fourth book.